IMAGES
of America

DALLAS'S
LITTLE MEXICO

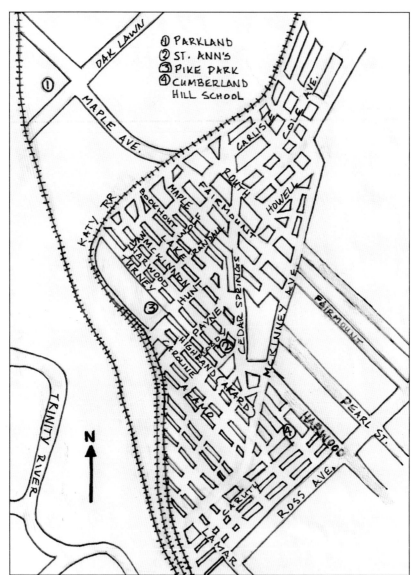

This map shows Dallas's Little Mexico area in about 1920. The neighborhood, or *barrio*, was just north of downtown and east of the Missouri, Kansas, and Texas (KATY) Railroad tracks. McKinney Avenue was the area's boundary on the east. The neighborhood extended north along Cedar Springs Road and McKinney Avenue to around Hall Street. This map shows the area before the Trinity River was rechanneled, moving it farther west and away from the city's central business district. The rechanneling also freed up new land immediately west of Little Mexico for use as an industrial corridor. (Courtesy of Angelynn G. Price.)

ON THE COVER: The most important Mexican holiday celebrated in Little Mexico was, and continues to be, Mexican Independence Day, *el Diez y Seis de Septiembre* (the 16th of September). Part of the festivities included the coronation of the holiday's queen. This 1928 photograph, taken at the Pike Park Recreation Center, shows the queen's coronation, her court, and musicians. Though a Mexican holiday, note the proud display of both an American and a Mexican flag. (Courtesy of the Dallas Mexican American Historical League.)

IMAGES
of America

DALLAS'S
LITTLE MEXICO

Sol Villasana

ARCADIA
PUBLISHING

Published by Arcadia Publishing
Charleston, South Carolina

Printed in the United States of America

Library of Congress Control Number: 2010940821

For all general information, please contact Arcadia Publishing:
Telephone 843-853-2070
Fax 843-853-0044
E-mail sales@arcadiapublishing.com
For customer service and orders:
Toll-Free 1-888-313-2665

Visit us on the Internet at www.arcadiapublishing.com

This book is dedicated to my mother, Rella, who first taught me the beauty and power of the written word.

CONTENTS

ACKNOWLEDGMENTS

Writing about history, like making it, is, at its best, a collaborative affair—this book is no different. I am indebted to countless people who have searched closets and attics for photographs and scoured their memories for information about what is now a lost neighborhood.

Important, too, in the development of this book has been the noble efforts of several individuals and groups with a special interest in Dallas's Mexican American history. Special thanks goes to Jesse and Nellie Tafalla, Pauline Marceleno Laws, Ana Laura Suacedo, and Albert Gonzalez of the Dallas Mexican American Historical League. My thanks also to Al Martinez of the Anita N. Martinez Archive, John A. Cuellar of the Cuellar Photographic Archive, Nora Betancourt of Casa Emanu-el United Methodist Church, Norma Lopez of Primera Iglesia Bautista, Olivia Rosales Sullivan of El Divino Salvador Presbyterian Church, Frances Gonzalez of the City of Dallas Parks and Recreation Board, and Isabelle Collora and Jim Harrell of the Association for Arts and Culture at the Our Lady of Guadalupe Catholic Cathedral. Juanita Chavoya Nanez was of very special assistance in giving this book not only content, but also direction. I must also thank Roberto Calderon, Ph.D., associate professor of history at the University of North Texas, for his insights. I am grateful to Leigh Ann Ellis for her earlier research on Little Mexico and for alerting me to Arcadia Publishing and its interest in this project. Arcadia's Kristie Kelly was a constant guide and helpful voice to me in the book's development.

Students of history are lucky to find institutional archivists who are both helpful and friendly. I am lucky to be able to say that about John A. Slate, archivist for the City of Dallas, Leslie A. Wagner of the Dallas Jewish Historical Society, Carol Roak of the Texas/Dallas History and Archives section of the Dallas Public Library, Steve Landregan of the Catholic Diocese of Dallas, Jorge Escobedo of the Dallas Museum of Nature and Science, Susan Richards of the Dallas Historical Society, and Cynthia Franco and Anne Peterson of the DeGolyer Library at Southern Methodist University. Especially kind and helpful was Juanelo Moa of the Lakewood branch of the Dallas Public Library system. Thanks go also to Michelle Shook of Crow Holdings.

All writers owe their families apologizes for the torture we put them through and very special thanks for their support. Such apologies and thanks go to my mother and stepfather, Rella and Joe Alvarez; my sister, Rella Rogers; and my nephew, Ari Lara. My cousins Charles Villasana, Yolanda V. Rodriguez, and Dr. Cervando Martinez have been especially kind to me. My *madrina*, Carmen "Nena" Gonzalez, who died at 96 while I worked on the book, deserves my gratitude for reminding me of the beauty of the Spanish language and for her constant love and affection. Without my father, Louis Villasana, who died in 2003, introducing me to the special world of Little Mexico during my youth, I doubt I could have come close to understanding or capturing the spirit of the barrio.

INTRODUCTION

At the end of the 19th century, Dallas was one of Texas's largest and most important cities. The trade in cotton, insurance business, banking, and, importantly, railroads, had assured Dallas's prominence in the emerging New South. The city's Southern heritage contributed to racial conflicts between African Americans and whites throughout the 20th century. But unlike most other large Southern cities, there was a third ethnic element in the social mix. Dallas had a quickly growing Mexican American population, a population that was also seeking the American dream. This is the story of that community's first foothold in Dallas; it is the story of Dallas's Little Mexico.

Mexicans have been part of Dallas since its beginning. However, Mexicans began to arrive in earnest with the city's first railroads in the 1870s. Many of the rail lines followed old trading routes familiar to Mexicans for generations. While not an old Spanish/Mexican town like San Antonio or El Paso, Dallas was, nonetheless, an important early trading center on the northern edge of Mexico's former province.

The social displacement caused by the violence of the 1910 Mexican Revolution was the impetus that propelled thousands of Mexicans to American cities, including Dallas. But unlike the Mexican traders, traveling in small groups or alone, who went back and forth between Mexico and the United States, these new immigrants came with their whole families and returning to Mexico was not assured. They needed to develop whole new communities.

As in many other cities, Dallas's early Mexicans often first settled along the town's railroad yards. There they could find shelter, sometimes an old rail car, and if they were lucky, work. Better-heeled immigrants could find cheap rentals in Dallas's old red-light district just north of downtown or in the older housing stock of an early Eastern European Jewish neighborhood a little farther north. This was to become Little Mexico, or as the residents called it, *La Colonia*, a distinct and vibrant neighborhood of modest homes, small businesses, churches, and schools. Further immigration from Mexico during the 1920s caused its numbers to boom. By the 1930s, Dallas's Little Mexico had grown to a population of over 15,000.

The Spanish language played a crucial role in Little Mexico's development and growth. Around the common language grew the barrio, or neighborhood. Since its founding, Texas had always been bilingual, but now with revolution and labor shortages caused by World War I, more than ever, Spanish brought together a people far away from home.

Language and family ties also connected Little Mexico to Dallas's other Mexican barrios in far West Dallas, around the Portland Cement Plant at Eagle Ford, and in old East Dallas, near the Houston and Central Texas Railroad Station. But Little Mexico was the major Mexican American community.

World War II saw a surge of patriotism from Dallas's Mexican immigrants. While many were not even citizens, hundreds went off to fight for their adopted country; many did not return. Those who did came home to Little Mexico with a new sense of not just being "Mexican" but of being "American." The GI Bill and other veteran benefits caused citizenship to rise, education levels to increase, political muscle to flex, and new Hispanic neighborhoods to develop.

The dispersal of the younger Mexican American population and post-war urban-renewal projects began to slowly dismantle Little Mexico. Developers also began to see the value of close to downtown living and entertainment projects. Many older Mexican Americans in Little Mexico were swindled out of their homes by less than honest developers. By the end of the 20th century, Little Mexico had all but disappeared, giving way to upscale, high-rise residences, office towers of steel and glass, and swank hotels. Two new downtown entertainment districts, Victory Plaza and the Harwood District, also emerged in Little Mexico's wake.

Today young Hispanics are rediscovering Dallas's Mexican roots through the schools and several special projects highlighting old neighborhoods like Little Mexico. This Images of America volume tells the visual story of the Little Mexico barrio at a time when the Spanish language is stronger and more vital than ever throughout not only the Southwest, but the entire nation. Using vintage and recent photographs provided by individuals, families, businesses, and organizations, this book paints a portrait of a rich cultural heritage.

One

BEGINNINGS

RAILROADS AND REVOLUTION

Texas is a big land. In the early 19th century, travel in Texas was difficult and dangerous. The Spanish royal roads tended to follow the old Indian trails (like the Shawnee Trail), which was a practice that was later copied by Anglo settlers. The National Central Highway (now Interstate 35) was from 1844 the major north-to-south road. At Dallas, it became Preston Road and went north to the Indian Territory at the Red River. The nation's post–Civil War need for goods and material, especially cotton and cattle, provided the economic stimulus for the growth of the Texas railroads.

In 1872, the Houston and Texas Central Railroad reached Dallas from the Port of Galveston. The Texas and Pacific Railroad soon ran from east to west through the growing city. The Missouri, Kansas, and Texas Railroad (KATY) followed the Shawnee Trail north from Dallas into America's heartland. By the beginning of the 20th century, Dallas was well established as a major rail hub.

All along the rail lines, Mexican workers assisted in the railroads' growth and settled near the tracks. In Dallas, Mexican railroad workers lived in makeshift camps near the stations or in the low-lying areas near the Trinity River just north of downtown. The area was first called Frogtown because of its proximity to a creek. The railroad workers, along with Mexican agricultural workers, began to develop an enclave where Spanish was spoken and a sense of community could flourish. Little Mexico was born.

By 1910, Gen. Porfirio Diaz had been Mexico's president for over 30 years. Most Mexicans were ready for political change, but when it came, it arrived in the form of a long and bloody revolution. Thousands of Mexicans fled with all they could carry and their families. Most were not sure when, or if, they could ever return. It is estimated that ten percent of Mexico's elite fled to Texas alone. When they arrived in Dallas, they further strengthened Little Mexico's position as North Texas's largest Mexican community.

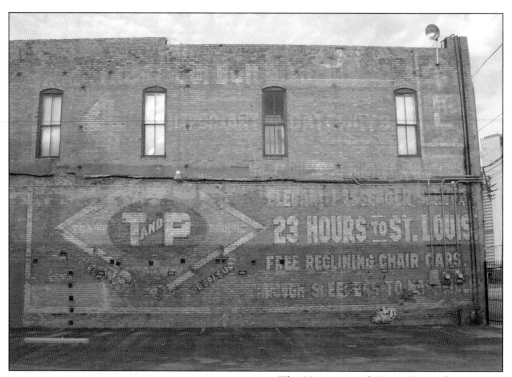

The Houston and Texas Central Railroad Depot once stood just a few blocks from this advertisement for the Texas and Pacific Railroad (T&P). The ad is on the side of a building at 2528 Elm Street, located in the Deep Ellum area of downtown. The T&P Railroad was the major east-to-west rail route through Dallas. (Author's collection.)

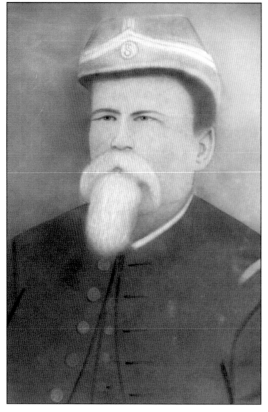

Many Mexican families, even those who had seen the violence of war before in Mexico's many martial conflicts in the 19th century, were moved to take radical action because of the revolution's excessive bloodshed. This image shows artillery captain Francisco Medellin of the Mexican army in about 1870. Captain Medellin was a career soldier who had fought against the French army at the battle of Puebla in 1862, the battle for which the now famous *Cinco de Mayo* holiday is celebrated. Captain Medellin's daughter Angelina married Constantino Villasana. When the Mexican Revolution came, the family moved to Texas, eventually settling in Dallas in 1920. (Author's collection.)

Jose Angel Alvarez was one of Gen. Francisco "Pancho" Villa's lieutenants during the bloody Mexican Revolution of 1910–1920. This photograph of Alvarez dates from immediately after the revolution, when he came to Texas. His son Isador settled and raised his family on Bookout Street in Dallas's Little Mexico. (Courtesy of Joe Alavarez.)

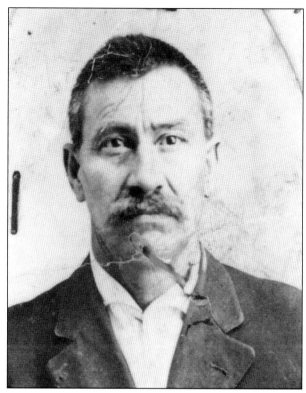

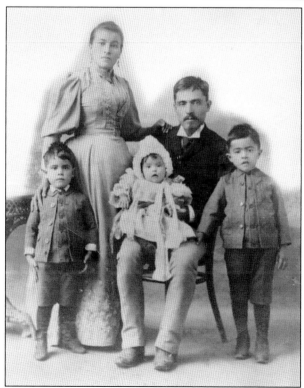

In 1901 when this photograph was taken, Constantino and Angelina Villasana were young parents of, from left to right, Rodolfo, Refugio, and Constantino II, in Mier y Noriega, Mexico. Though trained as a tailor, Constantino was a foreman on the La Cardono Hacienda of Matais Baez, one of the largest landowners in Northern Mexico. By the time the revolution came, the Villasanas had three other children, and the entire family was threatened by the rampaging violence. The Cuellar family, discussed further in the next chapter, had been from the same *hacienda* (ranch), and the Villasanas followed the Cuellar family first to rural Texas, then to Dallas. (Author's collection.)

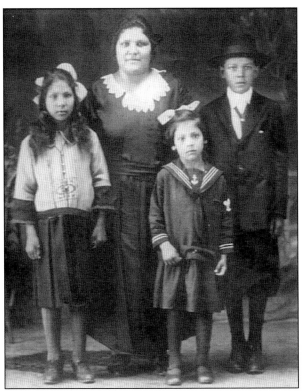

The Alagrin and Acosta families were also early Mexican settlers in Dallas's Little Mexico. This photograph of family members dates from about 1920. (Courtesy of the Dallas Mexican American Historical League.)

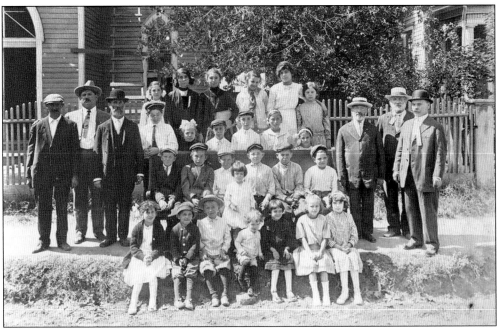

The first Mexican immigrants to the Little Mexico area in Dallas found what some Dallasites called Little Jerusalem. Eastern European Jews had settled there in the early 1900s. This photograph was taken in about 1916 and shows the congregation of Tiferet Israel on Highland, later Akard Street, in Little Mexico. (Courtesy of the Dallas Jewish Historical Society.)

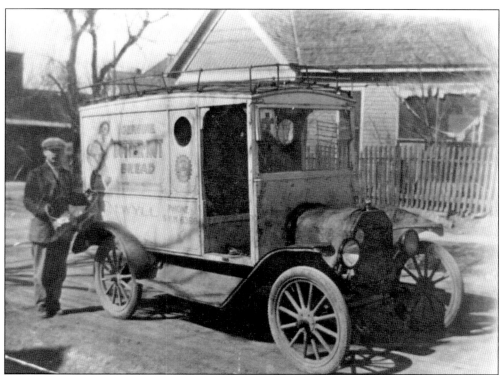

Isaac "Issy" Wyll delivered bread in the Little Mexico area. He is seen here next to his delivery truck in about 1917. The children of many early Mexican residents of Little Mexico later recalled speaking Yiddish before speaking English. (Courtesy of the Dallas Jewish Historical Society.)

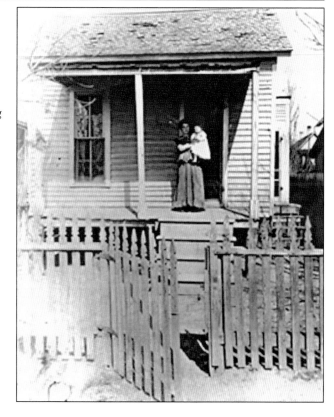

Issy Wyll and his family lived in this small house on Little Mexico's Caroline Street. The photograph dates from about 1916, the period when the area was transitioning from a Jewish to a Mexican neighborhood. (Courtesy of the Dallas Jewish Historical Society.)

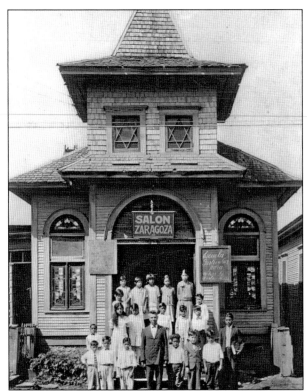

The buildings of Little Mexico began to change ownership and usage as World War I came to a close. Many of the Jewish families in Little Mexico began to move to South Dallas. Dating from about 1918, this photograph is of the Primera Iglesia Bautista, the First Mexican Baptist Church. The structure was located at 2211 ½ Alamo Street. The building had been the synagogue for Anshe Sphard, also known as the First Romanian-Austrian Congregation. Note the Star of David designs in the building's upper windows. (Courtesy of the Dallas Jewish Historical Society.)

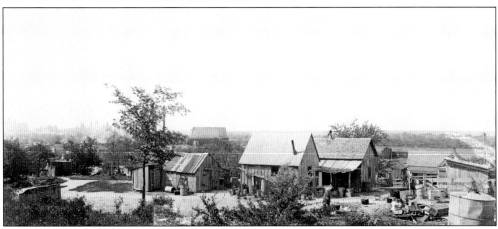

Mexican immigrants moving into the impoverished neighborhood of Little Mexico in the early decades of the 20th century found one amenity, Summit Park. The 4.39 acres were purchased by the City of Dallas from N. G. and James Turney and Mrs. L. F. White for $18,085 in 1912–1913. The park had a field house, or recreation center, which opened in 1915. The building had showers that proved valuable to the residents, since so few homes in the neighborhood had running water. The park also had a pool. By 1918, park attendance had reached 129,886. This 1912 photograph shows the Turney and White families' buildings on the property before the property was sold. The Turneys also contributed their name to Little Mexico's main street, Turney Street, which is now Harry Hines Boulevard. In 1927, the park's name was changed to Pike Park in memory of Edgar L. Pike, a city park board member. Pike Park was to become, and still is, the center of Little Mexico's social life. (Courtesy of the City of Dallas.)

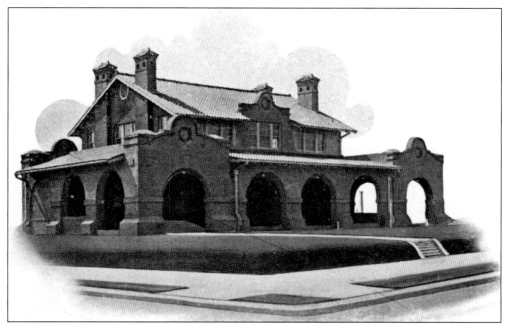

The recreation building, or field house, at Summit Park, later Pike Park, was finished in 1914. This photograph of the structure dates from about that time. It cost $23,750 to build. Lang and Witchell, one of the city's premier architectural firms, designed the building. (Courtesy of the City of Dallas.)

Pike Park's location on a chalky hill—the reason behind the Park's first name, Summit—caused the need for massive retaining walls. This 1916 photograph of the west-facing walls provides a view up the hill toward the field house. (Courtesy of the City of Dallas.)

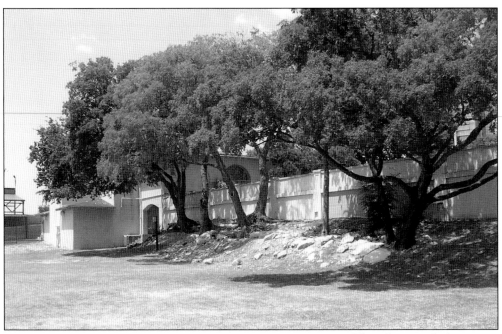

This photograph shows the same retaining walls at Pike Park today. (Author's collection.)

Guillermo Suarez was a young man from Dallas when he went off to serve his country in World War I. Corporal Suarez is seen in this 1918 photograph in France during the war. His granddaughter Frances Gonzalez, who is now a member of the City of Dallas's Park and Recreation Board, would marry Albert Gonzalez, who grew up in Little Mexico. (Courtesy of the Dallas Mexican American Historical League.)

Two

SOCIAL FOUNDATIONS
COMMUNITY LIFE IN THE BARRIO

The large numbers of Mexican refugees arriving in Dallas during the early years of the 1910 Mexican Revolution needed to find work and affordable housing. The city's old red-light district, called Frogtown, and the Eastern European Jewish neighborhood just north of downtown satisfied both requirements. By 1912, the city's leaders were cleaning up the red-light district, and landowners were shifting the properties' uses to warehousing and industrial purposes. The prospering Jewish community was slowly moving into South Dallas with its larger homes. Left behind for the Mexicans was a hodgepodge of small frame homes on very tiny lots and a few old two-story homes. About 95 percent of these houses were rental properties. The streets were unpaved, and there were no sidewalks.

The emerging Little Mexico barrio also contained several industrial use properties such as junkyards, packing plants, and a city dump. No doubt the people's health and comfort were affected by the foul chemical and animal smells. Then, of course, there were the railroads. The KATY line and its yards bordered the neighborhood on the west, closest to the Trinity River. People were often injured or killed on the tracks. Diseases, like tuberculosis, were common.

Despite these hardships, or perhaps because of them, there quickly emerged groups with the aim to address the physical and spiritual needs of Little Mexico's inhabitants. The Council of Jewish Women donated "penny lunches" to Mexican children at Cumberland Hill School on Akard Street. The Catholic Diocese established a mission in Little Mexico in 1914, followed soon after by the Guadalupe Church on the barrio's main thoroughfare, Turney Street, which is now Harry Hines Boulevard. The Mexican Baptist Church opened in 1918 in the former Romanian-Austrian synagogue at 2211 Alamo Street. By 1922, the Casa Emanu-el United Methodist Church had opened on North Akard. Community centers with clinics, like the Wesley and the Marillac Centers, opened their doors.

Associated with most of the churches were schools. The St. Ann's School, located adjacent to the Guadalupe Church, opened in 1927 and was to educate thousands of Little Mexico's children for more than four decades. William Travis Elementary and the Cumberland Hill School were the public primary schools for barrio kids. The old Dallas High School (later called Crozier Tech) in downtown Dallas served as the main high school.

The most significant location in Little Mexico was Summit, now called Pike Park. Founded in 1912–1913, the small park sat upon a chalk hill at the barrio's north end. It contained a recreation center and a pool. It was the focal point for Little Mexico's public celebrations. But racism was never far away. In the park's early years, Mexican children were not allowed in the public pool, while white children swam.

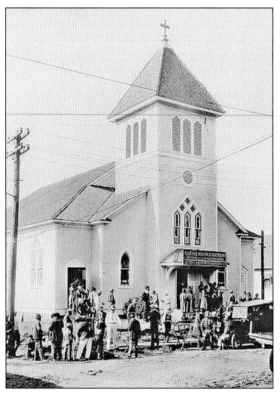

Religious organizations in Dallas were quick to respond to the spiritual and physical needs of the thousands of Mexican refugees fleeing the 1910 Mexican Revolution. The Catholic Diocese of Dallas established a Catholic Mission in 1914. By 1925, the Diocese dedicated Our Lady of Guadalupe Church on a corner of a block it owned at Turney (now Harry Hines Boulevard), Moody, Harwood, and Wichita Streets. This photograph of the church dates from the early 1930s. Our Lady of Guadalupe is the Patron Saint of Mexico, and it was natural for the church to appeal to its flock with this direct reference to their home country's most significant religious icon. The congregation was eventually merged into the downtown cathedral, Sacred Heart (originally an Irish and German congregation), and renamed Our Lady of Guadalupe Cathedral. The old church was destroyed in a fire in the 1980s. (Courtesy of the Mexican American Historical League.)

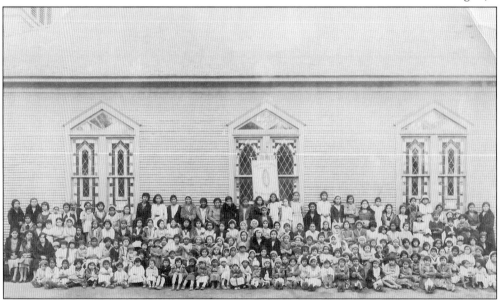

Our Lady of Guadalupe Catholic Church was a center of religious life for not only Mexican Americans in Little Mexico but also for Spanish-speaking immigrants throughout the Dallas area. Residents of another early Mexican barrio at the Portland Cement plant, located several miles west of Dallas, would walk the T&P Railroad tracks to Little Mexico on Sundays to attend Mass. This 1933 photograph of a Catechism class provides a view of the church's north facade. (Courtesy of the Catholic Diocese of Dallas.)

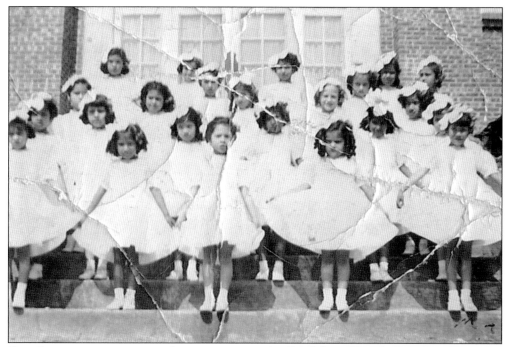

First Communions were a regular occurrence at the Guadalupe Church Complex. This 1930s photograph shows one such First Communion taken on the front steps of the St. Ann's School, which was adjacent to the church. (Courtesy of the Dallas Mexican American Historical League.)

This photograph, which dates from about 1966, shows the spire of the Guadalupe Church and the large house used as a home by the Sisters of Charity, the order in charge of instruction at St. Ann's School. (Courtesy of Casa Emanu-el United Methodist Church.)

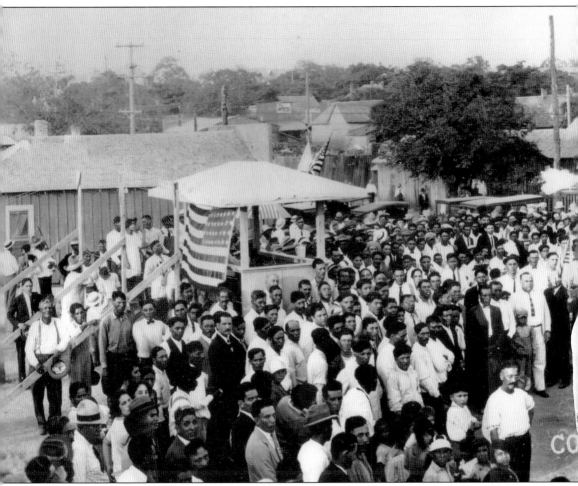

At first, Mexican children competed with Jewish children for the use of Pike Park's meager facilities, especially the pool. Mexican children were prohibited from using the pool on certain days of the week. By the 1920s, the park was almost exclusively used by Mexican Americans and hosted all fashions of celebrations. This 1926 photograph shows a Fourth of July celebration at Pike Park.

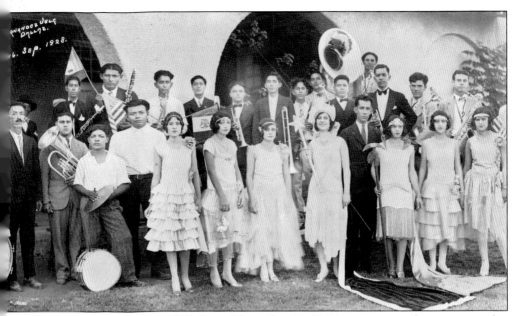

The most important Mexican holiday celebrated in Little Mexico was, and continues to be, Mexican Independence Day, el Diez y Seis de Septiembre. The festivities included dances, music, and food prepared by local residents. This 1928 photograph taken at the Pike Park Recreation Center shows the queen's coronation, her court, and musicians. (Courtesy of the Dallas Mexican American Historical League.)

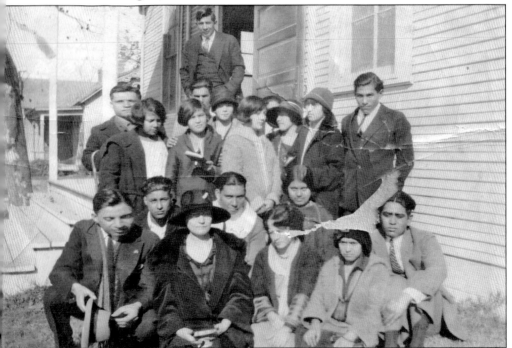

While many residents of Little Mexico were Catholic, certainly not all were. This 1931 photograph shows the front of Emanu-el United Methodist Church on Akard Street. The church had been founded years before in Little Mexico. (Courtesy of Casa Emanu-el United Methodist Church.)

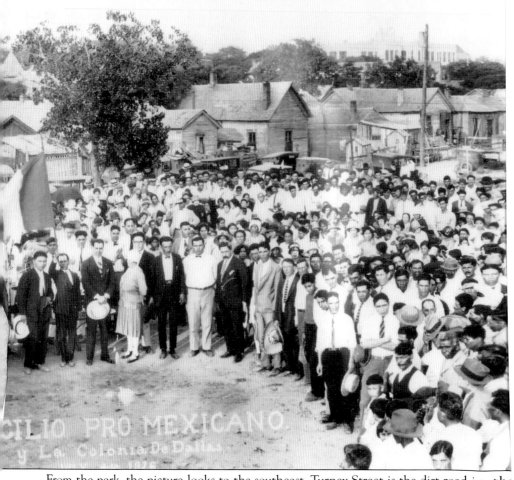

From the park, the picture looks to the southeast. Turney Street is the dirt road in the ground directly behind the crowd and lined cars. Note both the American and the Mexica Even at this early date, Little Mexico's population was demonstrating a love for its newly country. (Courtesy of the Dallas Mexican American Historical League.)

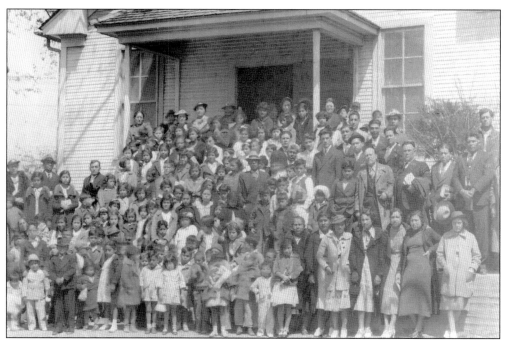

The Emanu-el Mexican Methodist Church on Akard Street was a simple wood-framed structure. This photograph shows the congregation on the church's front steps in 1937. (Courtesy of Casa Emanu-el United Methodist Church.)

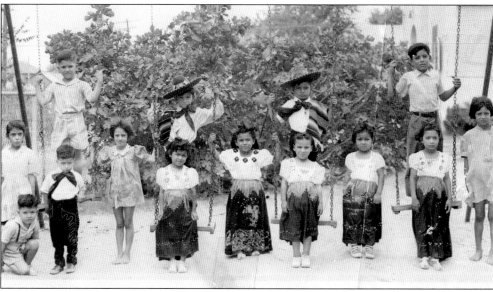

While the Mexican Presbyterian Church in Dallas started its work in the Little Mexico area as early as 1912, it was not until 1923 that it secured a property at 1803 Payne Street, near Akard Street. The two-story structure had been the Presbyterian Settlement House. The church was known as El Divino Salvador Presbyterian Church. Its first minister was Elias S. Rodriguez. This photograph from 1939 shows the church's playground, attached to its school, and kindergarten children. The large fig tree in the background was a source of treats for the children. (Courtesy of El Divino Salvador Presbyterian Church.)

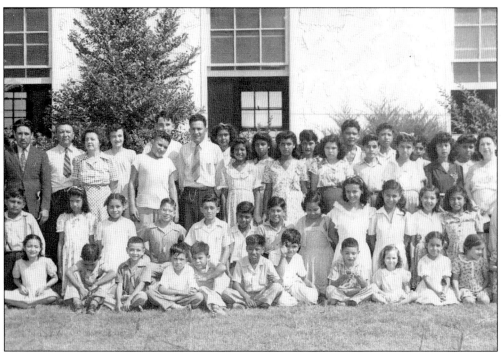

This 1945 photograph shows El Divino Salvador's youth group outside of the church on Payne Street in Little Mexico. (Courtesy of El Divino Salvador Presbyterian Church.)

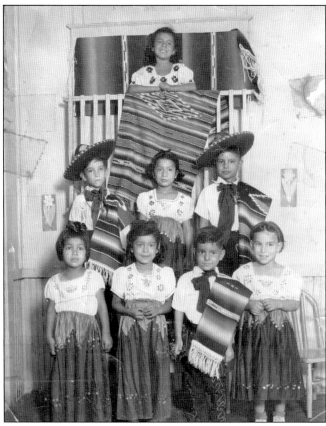

These children of El Divino Salvador Presbyterian Church were preparing for a show highlighting their Mexican culture. The photograph was taken in the church's interior in 1939. Olivia Rosales is second from the left in the first row. (Courtesy of El Divino Salvador Presbyterian Church.)

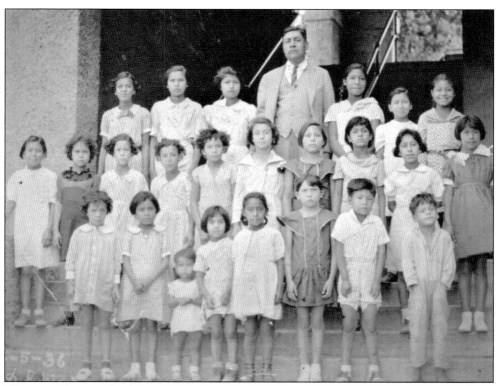

This 1936 photograph of the children of Emanu-el United Methodist Church shows them at Pike Park. The park was a favorite summertime get-away for the children of Little Mexico. (Courtesy of Casa Emanu-el United Methodist Church.)

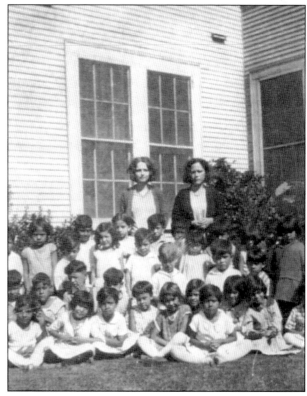

The Emanu-el Methodist School met at the Wesley Community Center across the street from the church. This 1930 photograph shows the children and their teachers in the community center's side yard. (Courtesy of Casa Emanu-el United Methodist Church.)

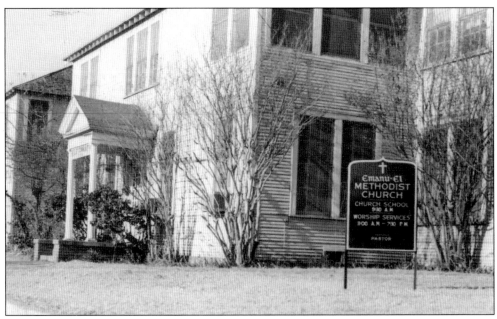

This 1940s photograph shows the Wesley Community Center's facade with a sign for Emanu-el Church, which stood across the street. (Courtesy of Casa Emanu-el United Methodist Church.)

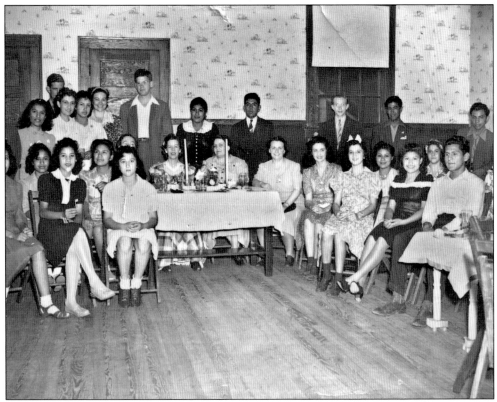

The Wesley Center was a rambling, two-story affair. This 1944 photograph shows the youth of Emanu-el Church inside the center. (Courtesy of Casa Emanu-el United Methodist Church.)

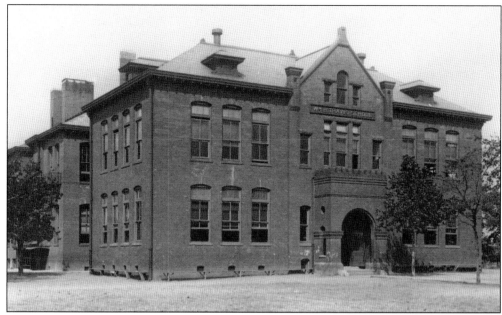

While Little Mexico's churches usually had small schools associated with the congregations, the public schools also provided an alternative. The first William B. Travis Elementary School was a typical two-story public school. It was located at Little Mexico's northern edge, on McKinney Avenue. This structure fell victim to arson in the 1950s. The second Travis school stands in its spot today. (Courtesy of Dallas Mexican American Historical League.)

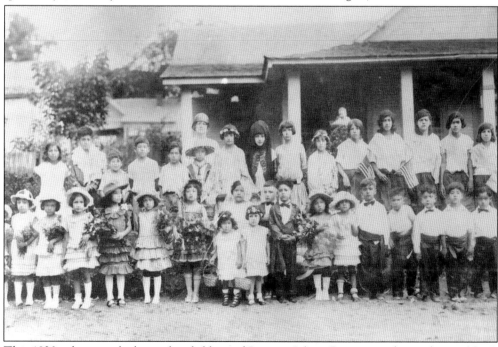

This 1930s photograph shows the children of Primera Iglesia Bautista in front of a neighbor's house on Harwood Street after the congregation moved to its second Little Mexico location on Payne at McKinnon Streets. (Courtesy of Primera Iglesia Bautista.)

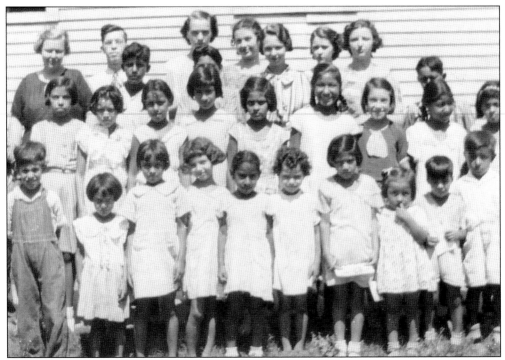

Here are children from the vacation Bible school of Primera Iglesia Bautista during the 1930s. (Courtesy of Primera Iglesia Bautista.)

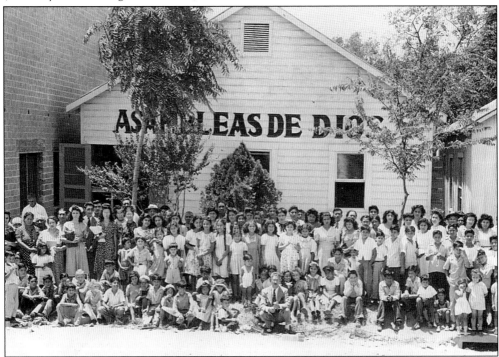

The Assembly of God also had a presence in Little Mexico. This is the church on Harwood Street in 1947. (Courtesy of Dallas Mexican American Historical League.)

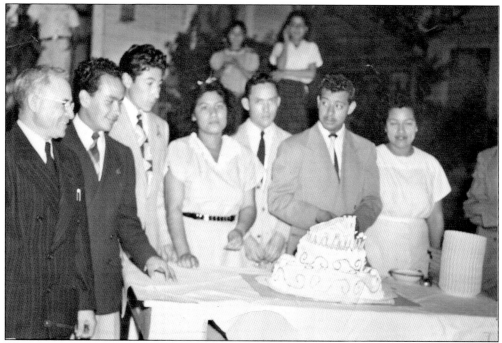

Church picnics were common in Little Mexico. This photograph shows the celebration of the 25th anniversary party of Emanu-el United Methodist Church. (Courtesy of Casa Emanu-el United Methodist Church.)

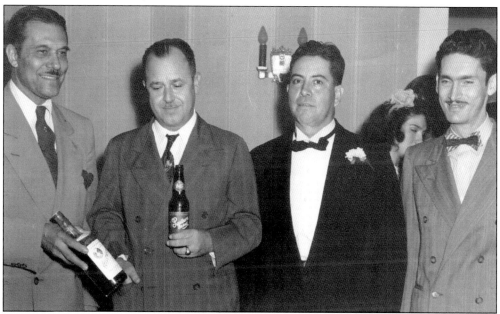

Weddings were special occasions in Little Mexico. Most families in the barrio knew each other, and the joining of families through marriage was often an elaborate affair. This 1947 photograph is from the wedding of Dora Villasana to Braulio Zapata, who was one of Dallas's first Hispanic police detectives. Second from left is Dr. Julian T. Saldivar, and to his left is the bride's father, Rodolfo Villasana. (Courtesy of Dolores Saldivar Brown.)

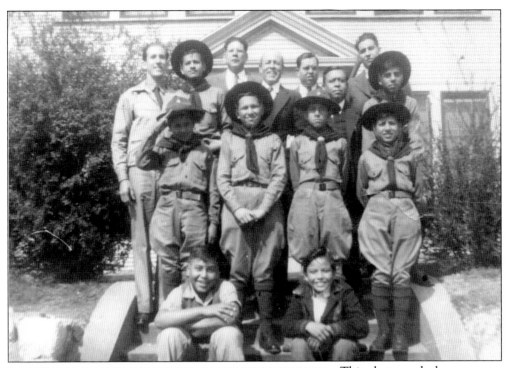

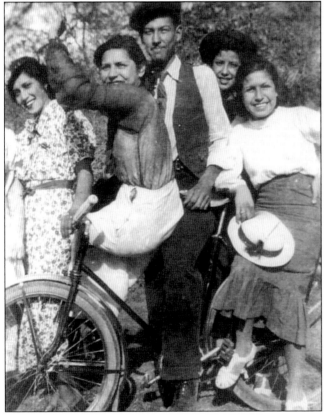

This photograph shows a group of Boy Scouts in Little Mexico in front of the Wesley Center. The Methodist church formed the first Boy Scouts organization in Little Mexico in the early 1930s. The original troop was called El Exploradores. Tomas Hernandez is third from left in the back row. (Courtesy of Casa Emanu-el United Methodist Church.)

Not all public events in Little Mexico involved church. Here Little Mexico residents enjoy a bike ride around the neighborhood in the 1930s. (Courtesy of Dallas Mexican American Historical League.)

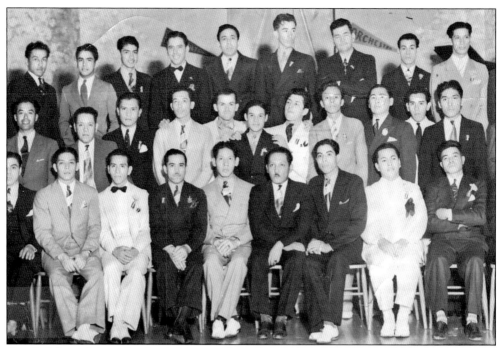

Social clubs proliferated in Little Mexico. Here the members of Club Amado Nerva, named for Mexico's foremost poet, pose for the camera in 1938. (Courtesy of Dallas Mexican American Historical League.)

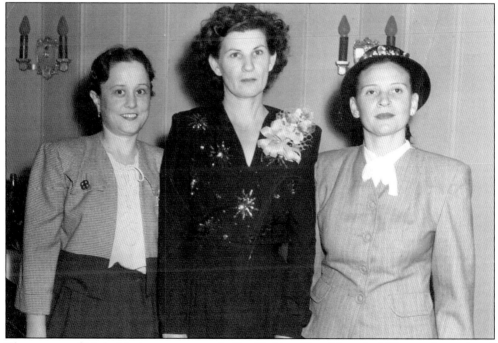

The women of Little Mexico were a proud, dignified lot. Here Magarita Villasana (center) and Maria Saldivar, to her left, have their photograph taken at a family wedding. (Courtesy of Dolores Saldivar Brown.)

Women's organizations were particularly popular in Little Mexico. Club Camilia was, perhaps, the most popular. This photograph of Club Camilia members dates from 1948. (Courtesy of Dallas Mexican American Historical League.)

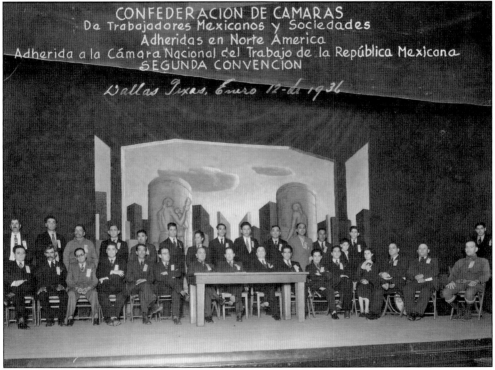

Labor organizations had a long tradition in Mexico, and the Great Depression only intensified worker activity in the 1930s. Members of the Confederacion de Camaras de Trabajadores Mexicanos are shown here in 1936 at their first convention in Dallas. (Courtesy of Dallas Mexican American Historical League.)

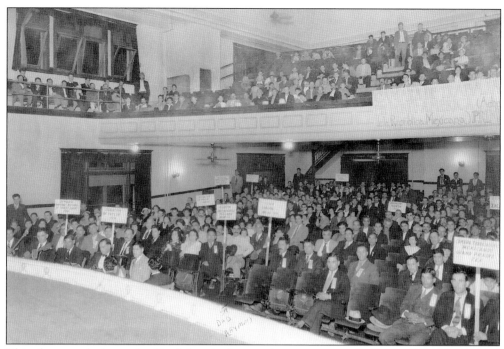

This photograph shows the Confederation's second convention in Dallas in 1937. (Courtesy of Dallas Mexican American Historical League.)

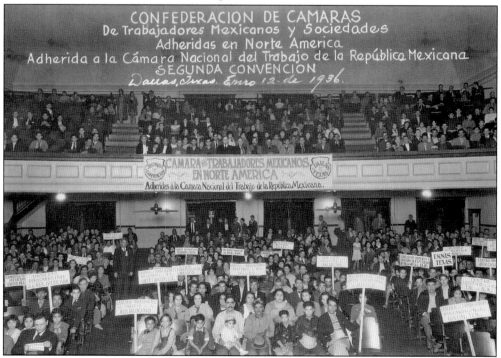

This photograph, which was taken at the same convention that is illustrated in the picture above, shows the Confederation's delegates from various communities throughout the United States. (Courtesy of Dallas Mexican American Historical League.)

LA BELLA Y DISTINGUIDA DAM

Josefina Guedea

Que hoy ennoblece nuestra Colonia forman
te de ella, honra al Obre¡o y al Mexica¡
razon permitiendonos lanzar su candidatur

ULTIMO COMPUT(

8330

Votos en su favor

Vote Ud. por ella

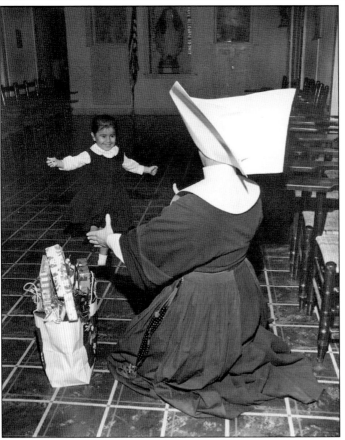

Labor groups promoted their agendas through wonderfully inventive techniques. This 1936 ballot is for the election of the queen of the workers' organizations. Josefina Guedes, not too surprisingly, went on to win the contest. (Courtesy of Juanita Chavoya Nanez.)

The Sisters of Charity, who taught at the St. Ann's School in Little Mexico, were easily distinguished by their elaborate habit. In this photograph from the 1940s, Sr. Viola Brown greets a young member of Little Mexico's community at the Marillac Center. (Courtesy of Catholic Diocese of Dallas.)

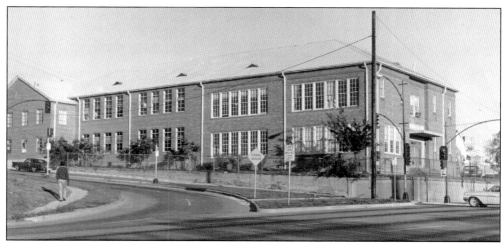

The old Our Lady of Guadalupe Church complex also contained a rectory and a small school, which started with 176 pupils and an old frame house. The wooden house soon proved inadequate for the growing number of Catholic Mexican and Mexican American children in Little Mexico. A $15,000 donation from Ann Kilgallen of Chicago allowed for the construction of the St. Ann's School (elementary), located next to the church. The school opened in 1927, and classes were full, with tuition running $1 per week. This photograph of the school dates from the early 1960s. The Our Lady of Guadalupe Church and St. Ann's School complex was a center for Catholic life in Little Mexico. Marriages and funerals were held at the church; hundreds of children were educated at the school, and countless proms, concerts, and sporting events were held there as well. With the loss of population in Little Mexico and better educational opportunities for Mexican American children, the school was abandoned by the 1980s. (Courtesy of the Dallas Mexican American Historical League.)

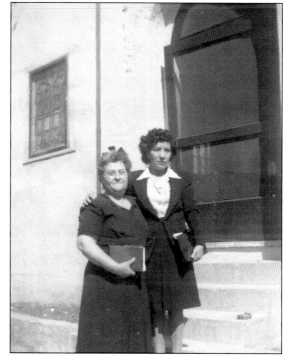

The education of their children was paramount to Little Mexico's parents. This 1940s photograph shows a student and teacher at El Divino Salvador Presbyterian Church at 1803 Payne Street in Little Mexico. The church began using the old Presbyterian Settlement House, and with some additions and alterations, it became a sanctuary in 1923. (Courtesy of El Divino Salvador Presbyterian Church.)

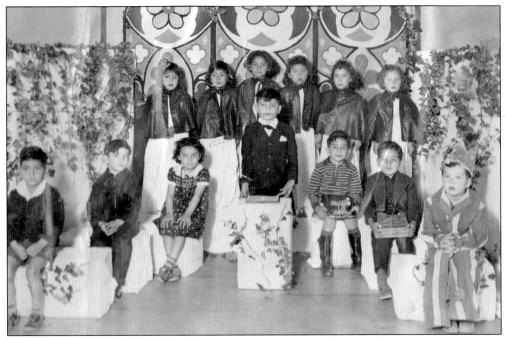

With few resources aimed at Dallas's Hispanic children, Little Mexico's churches were kept busy entertaining a quickly growing Hispanic population. El Divino Salvador Presbyterian Church's kindergarten was known for its elaborate children's plays. This photograph is of one such play from the early 1940s. (Courtesy of El Divino Salvador Presbyterian Church.)

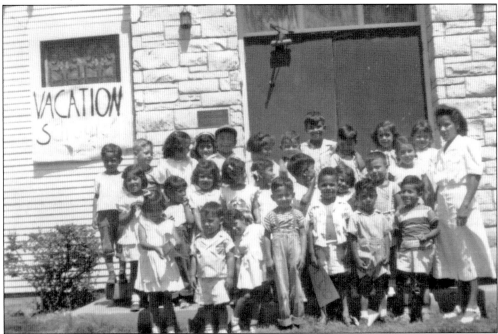

El Divino Salvador Presbyterian Church had several programs directed at Little Mexico's youth. This photograph, from about 1940, shows the church's vacation Bible school class. (Courtesy of El Divino Salvador Presbyterian Church.)

Women were the backbone of Little Mexico's many churches. This 1941 photograph shows the women of El Divino Salvador Presbyterian Church. (Courtesy of El Divino Salvador Presbyterian Church.)

The congregation of El Divino Salvador Presbyterian Church, located on Payne Street at Akard Street, poses for the camera in 1943. (Courtesy of El Divino Salvador Presbyterian Church.)

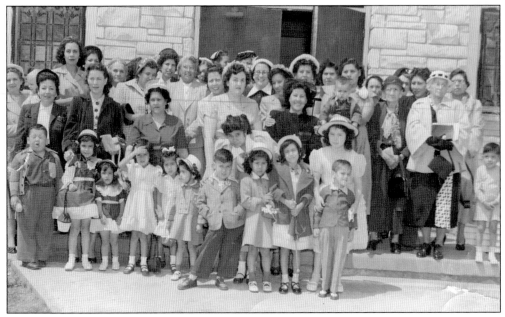

This 1950 photograph shows the congregation of El Divino Salvador Presbyterian Church at its new location on Carlisle Street, near the northern edge of Little Mexico. (Courtesy of El Divino Salvador Presbyterian Church.)

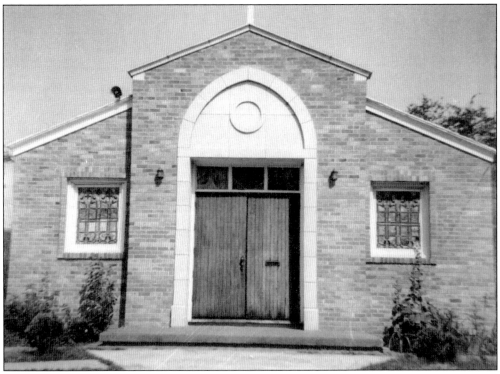

El Divino Salvador Presbyterian Church moved to its second location at 2909 Carlisle Street in late 1949. This photograph, which is from that period, shows the church's new brick facade. (Courtesy of El Divino Salvador Presbyterian Church.)

This photograph shows El Divino Salvador Presbyterian Church's third, and present, building on Angora Street, well away from Little Mexico, which nurtured it for half a century. The church moved to this site in the 1960s, when the population of Little Mexico was clearly in decline. (Courtesy of El Divino Salvador Presbyterian Church.)

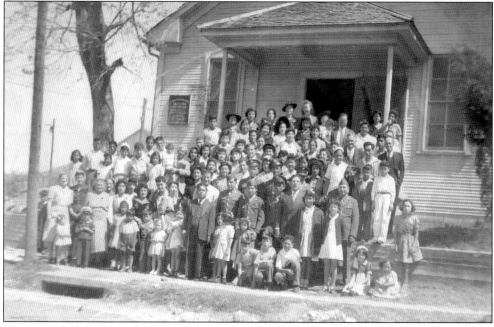

This 1943 photograph of the congregation of Emanu-el United Methodist Church, taken in front of its simple building on Akard Street, illustrates one of the most socially active and progressive churches in Little Mexico. Note the servicemen in uniform, serving their country during wartime. (Courtesy of Casa Emanu-el United Methodist Church.)

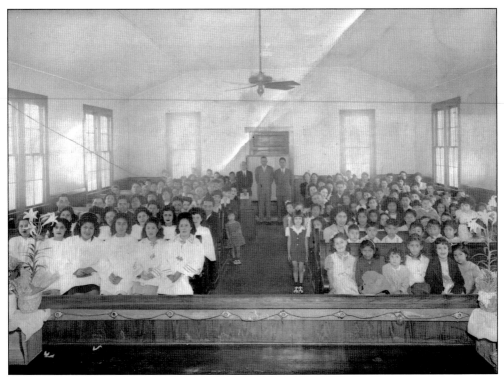

Though housed in a small building, Emanu-el United Methodist Church had a large membership. This 1946 photograph shows the congregation inside the sanctuary. (Courtesy of Casa Emanu-el United Methodist Church.)

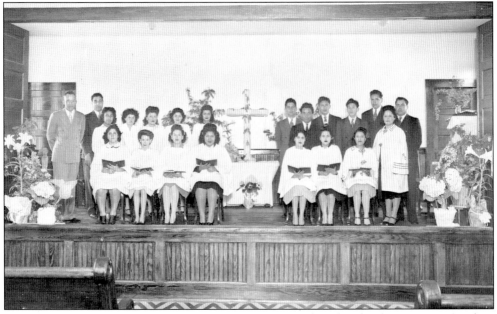

While its congregation was sizable, Emanu-el United Methodist Church's choir was more modest. This 1945 photograph shows the choir at the church's altar. (Courtesy of Casa Emanu-el United Methodist Church.)

Emanu-el United Methodist Church had grown in prominence, as well as size, since its founding in the early 1920s in Little Mexico. By the early 1940s, it had established a mission church in the Mexican barrio just east of downtown. This 1942 photograph shows the church's Floyd Street Mission, which met in the house of Maria Moreno. Eventually, the Mission became the Agape United Methodist Church, which, located in its own new building, continues to serve east Dallas's Hispanic community. (Courtesy of Dallas Mexican American Historical League.)

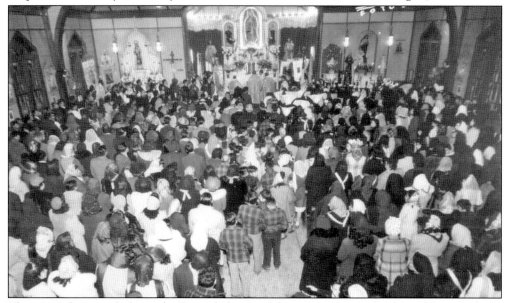

This 1944 photograph shows the Fiesta de las Guadalupanas at Our Lady of Guadalupe Catholic Church in Little Mexico. (Courtesy of Catholic Diocese of Dallas.)

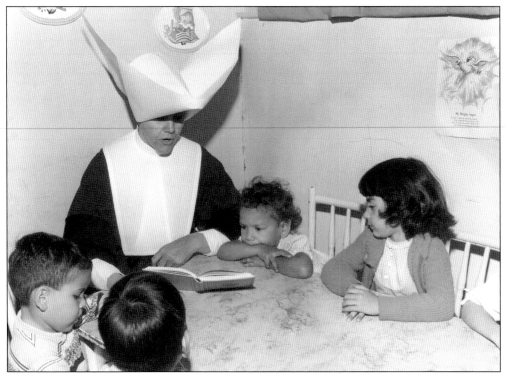

The Marillac Center was Our Lady of Guadalupe Catholic Church's community center. This 1940s photograph shows the center's director, Sr. Elizabeth Hughes, reading to children. (Courtesy of Catholic Diocese of Dallas.)

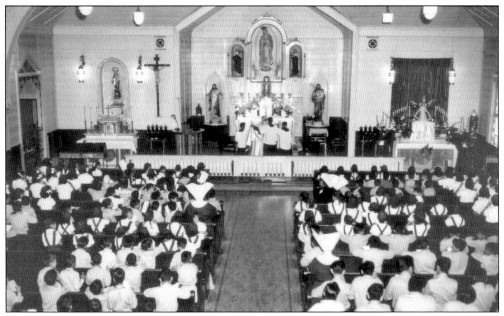

The substantial size of Our Lady of Guadalupe Church is visible in this 1940s photograph of the church's interior. Note the Virgin of Guadalupe icon over the altar. (Courtesy of Catholic Diocese of Dallas.)

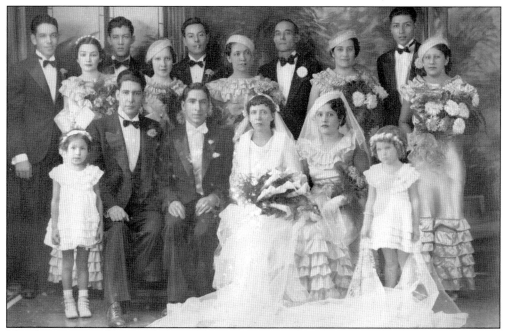

This formal 1936 photograph shows the wedding party for the marriage of Cervando Martinez to Maria Villasana. The Martinezes and Villasanas were from the same general area in Mexico, a not too uncommon fact, contributing to the families settling in the same locations once they migrated to the United States. (Courtesy of Dallas Mexican American Historical League.)

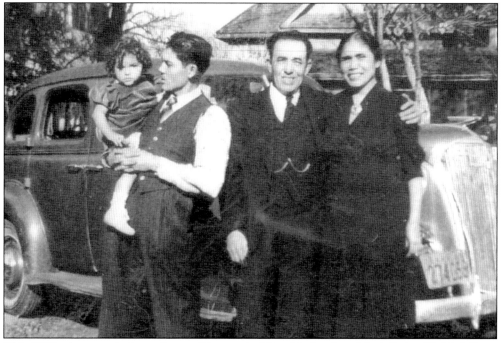

This 1940s photograph shows Ernest Chavoya holding his daughter Maria Luisa. To his left are his parents, Tereso and Juanita Chavoya. The Chavoyas lived on Carlisle Street on Little Mexico's northern edge. (Courtesy of Juanita Chavoya Nanez.)

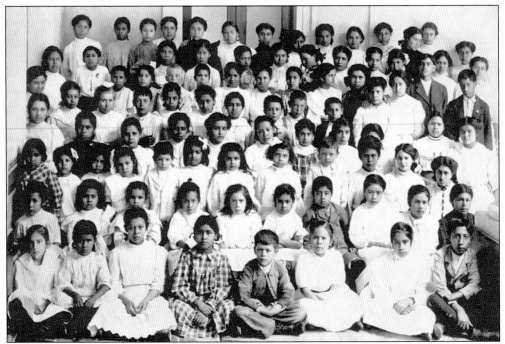

William B. Travis Elementary School, situated on Little Mexico's northern border, was the primary public school for the barrio's children. This early 1920s photograph shows a group of the school's children. (Courtesy of Dallas Mexican American Historical League.)

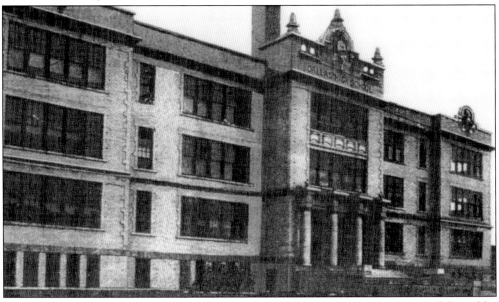

Located on the eastern edge of the city's downtown, Dallas High School was one of the public school district's oldest structures, dating from about 1907. In the early 20th century, the school was renamed Crozier Tech High School and was the main secondary school for Little Mexico's children. With the decline in student population in Little Mexico during the 1960s and 1970s, the school was closed, and the property was sold in the late 1990s. It now stands vacant and boarded-up in the midst of the city's skyscrapers. (Courtesy of Dallas Mexican American Historical League.)

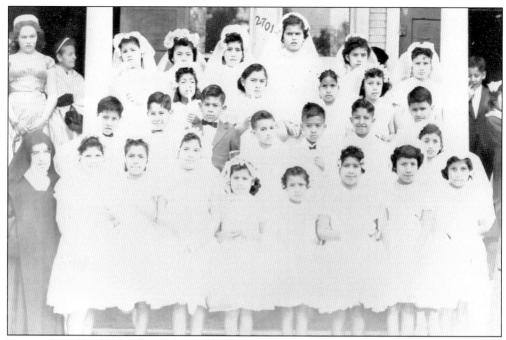

Dating from the 1920s, this photograph shows a First Communion class of St. Rosa de Lima Catholic Church in El Poso, a small Mexican neighborhood southeast of Little Mexico. (Courtesy of Dallas Mexican American Historical League.)

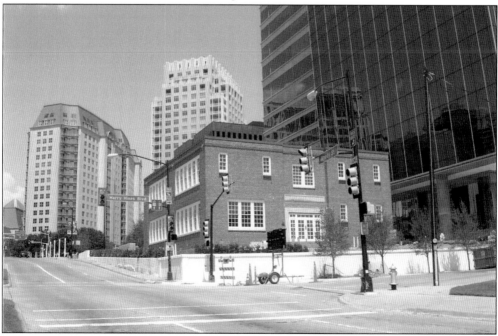

Here is the former St. Ann's School, as it appears today on Harry Hines Boulevard at Wichita Street. The building is now a restaurant and part of the St. Ann Court mixed-use development by Harwood International, presently one of the largest landowners in what was once Little Mexico. The area is now known as the Harwood District. (Author's collection.)

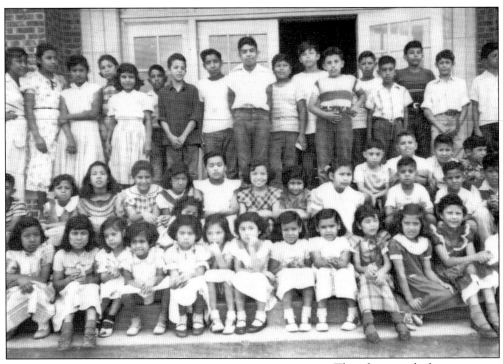

This photograph shows one of St. Ann's religion classes on the school's front steps in about 1955. (Courtesy of Dallas Mexican American Historical League.)

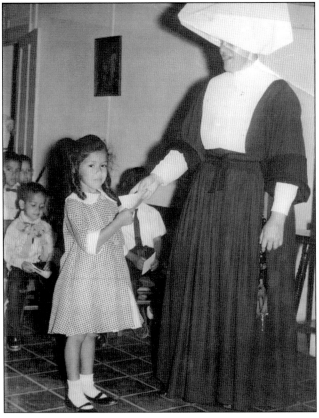

A St. Ann's student receives an accolade from one of the sisters in this 1950s photograph. (Courtesy of Dallas Mexican American Historical League.)

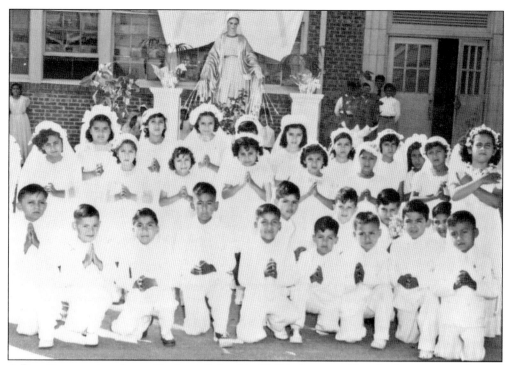

A First Communion class at St. Ann's School in 1948 is shown smiling for the camera in front of the school's southern facade. (Courtesy of Dallas Mexican American Historical League.)

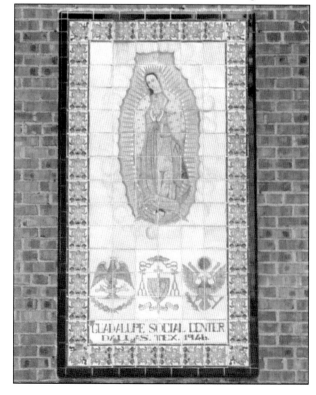

On the outer side of the wall surrounding the St. Ann's School Complex was this tile mosaic of the Virgin of Guadalupe, located on Harwood Street. The roughly 4-by-8-foot mural was installed on the wall in 1946. When the St. Ann's School Building was adapted into the St. Ann Court complex beginning in 2007, the mosaic was carefully removed for restoration. Made of soft-glazed, Mexican-terracotta tiles, the mural is thought to be the work of Octavio Medellin, an artist born in Mexico in 1908, who studied at the San Antonio Art School. Medellin worked and taught in Dallas from 1942 to 1977. The mural is now installed in the gardens of Harwood International's St. Ann Court complex. (Courtesy of Isabelle Collora.)

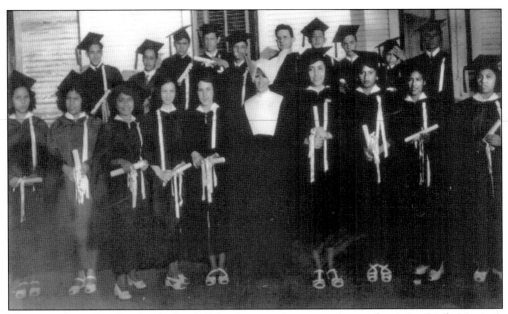

The secondary school at the St. Ann's School was, at first, geared toward training Little Mexico's girls. Eventually boys were admitted, but girls would tend to outnumber them until the school's closing. This 1950s photograph of the high school graduating class illustrates that point. (Courtesy of Dallas Mexican American Historical League.)

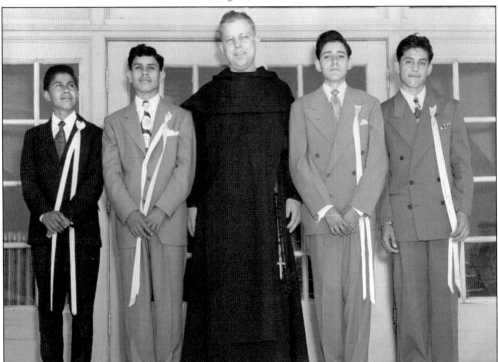

St. Ann's 1948 graduating class was composed of four young men. Pictured are, from left to right, Joe Alvarez; Frank Cruz; Father Gabriel, one of the priests at Our Lady of Guadalupe Church; Raymond Santos; and Edward Diaz. (Courtesy of Joe Alvarez.)

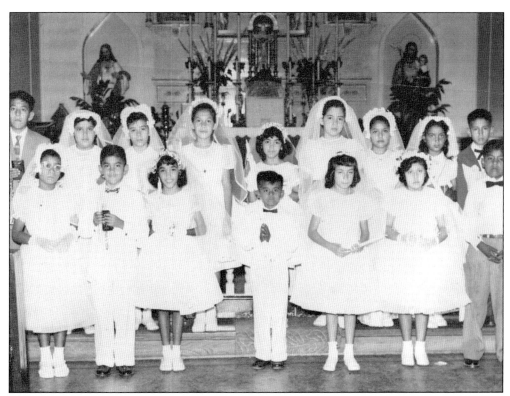

This 1958 First Communion photograph was taken inside the Our Lady of Guadalupe Church on Harry Hines Boulevard in Little Mexico. (Courtesy of Dallas Mexican American Historical League.)

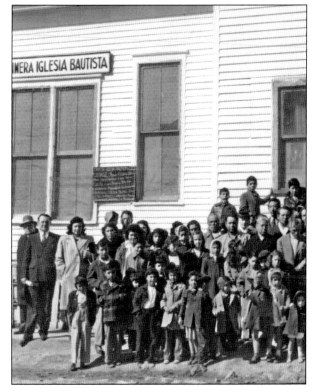

Primera Iglesia Bautista's second location in Little Mexico was at 2013 Payne Street, near McKinnon Street. This 1940s photograph shows members of the congregation outside the church with their then pastor, Mr. Montero, at the far left in the suit. The chalkboard that is pictured was used for notices on the building's wall. The church employed the same chalkboard for the same purposes at its original location (see photograph on page 14). (Courtesy of Primera Iglesia Bautista.)

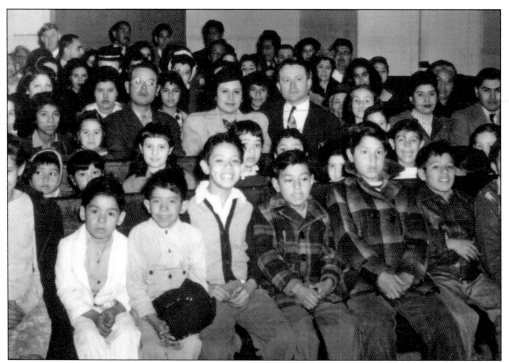

The children of Primera Iglesia Bautista ham it up for the camera in this 1940s picture. (Courtesy of Primera Iglesia Bautista.)

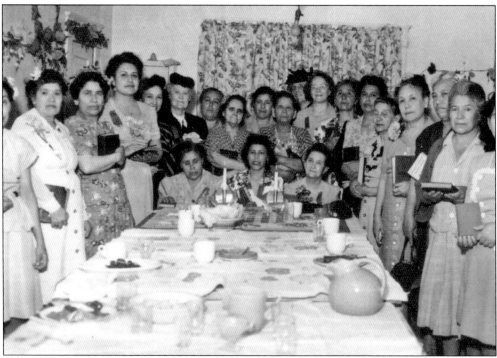

The busy women of Primera Iglesia Bautista stop for a moment for the camera at a church potluck dinner in this 1940s photograph. (Courtesy of Primera Iglesia Bautista.)

In the 1960s, Primera Iglesia Bautista moved into this fine brick structure on Fairmount Street, on the northern edge of Little Mexico. (Courtesy of Primera Iglesia Bautista.)

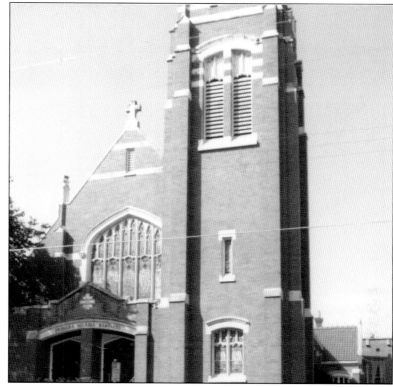

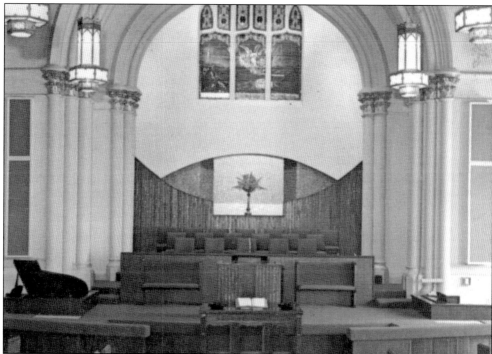

This 1960s photograph shows the sanctuary of Primera Iglesia Bautista's new building on Fairmount Street. (Courtesy of Primera Iglesia Bautista.)

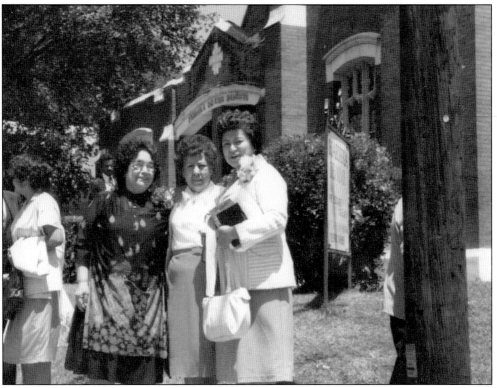

In this 1965 photograph, members of Primera Iglesia Bautista pose in front of their new church building, located on Fairmount Street. (Courtesy of Primera Iglesia Bautista.)

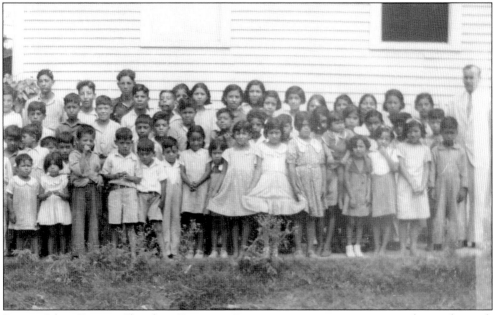

Primera Iglesia Bautista Church on Fairmount Street was a vast improvement over the simple wood-framed building it occupied at 2013 Payne Street. The exterior of the Payne Street location can be seen in this 1936 photograph of the church's youth. (Courtesy of Primera Iglesia Bautista.)

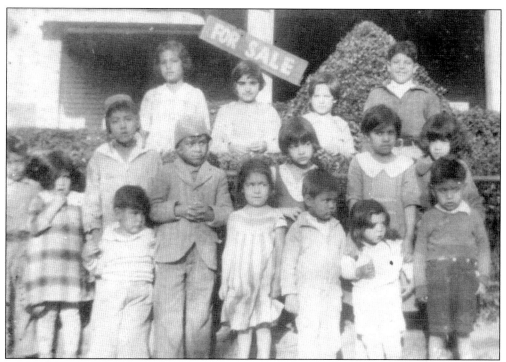

Some of the children of Primera Iglesia Bautista pose in front of a home in Little Mexico in 1933. (Courtesy of Primera Iglesia Bautista.)

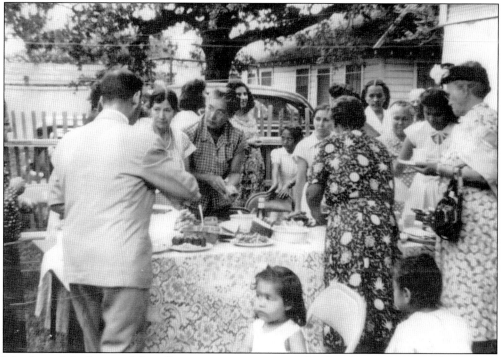

Members of the Primera Iglesia Bautista enjoy a picnic on the church's modest grounds on Payne Street in 1943. (Courtesy of Primera Iglesia Bautista.)

Here is the impressive current building for Primera Iglesia Bautista in north Dallas. (Courtesy of Primera Iglesia Bautista.)

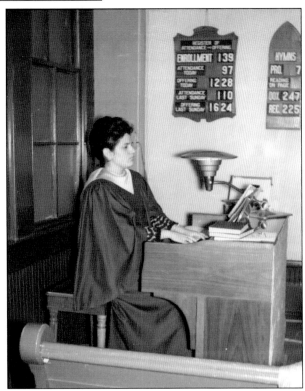

This photograph shows organist Teresa Santilla at Emanu-el United Methodist Church at its Akard Street location in 1957. (Courtesy of Casa Emanu-el United Methodist Church.)

Reverchon Park was located on Little Mexico's northern border. The park, with its tall pecan trees, creek, and artesian well, was a favorite recreation spot for residents. The site was a far cry from Pike Park's spartan landscape. This 1943 photograph shows a church picnic at Reverchon Park. (Courtesy of Casa Emanu-el United Methodist Church.)

This 1940s picture shows Emanu-el United Methodist Church's youth group preparing to depart on a road trip to a Methodist summer camp in central Texas. (Courtesy of Casa Emanu-el United Methodist Church.)

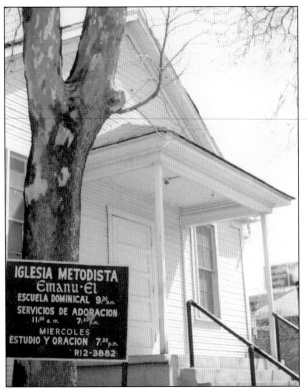

By the early 1960s, Emanu-el United Methodist Church had outgrown its small, wood-framed building on Akard Street. This 1963 photograph illustrates the structure's simple, yet elegant, beauty. (Courtesy of Casa Emanu-el United Methodist Church.)

After Easter services in 1964, an unknown photographer snapped this picture of the members of Emanu-el United Methodist Church leaving the building. (Courtesy of Casa Emanu-el United Methodist Church.)

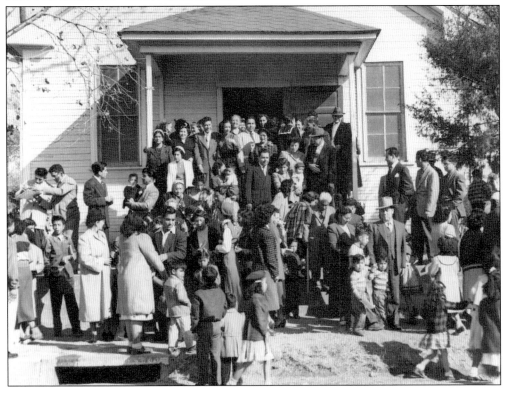

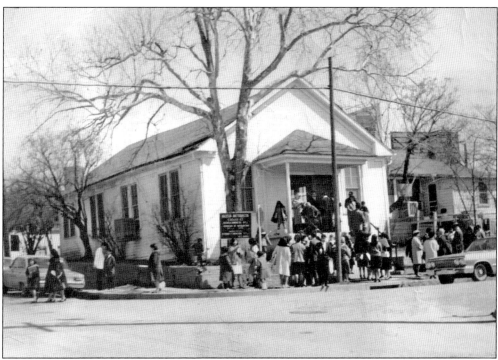

This 1966 picture clearly shows Emaun-el United Methodist Church at its first location at the corner of Akard and Payne Streets. (Courtesy of Casa Emanu-el United Methodist Church.)

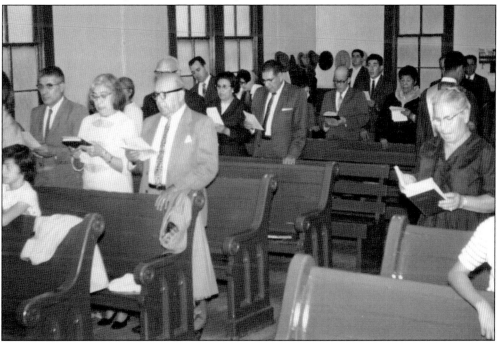

The congregation of Emanu-el United Methodist Church joins in song in this 1964 photograph. Cuca and Pablo Verver (in glasses) are the couple at left. (Courtesy of Casa Emanu-el United Methodist Church.)

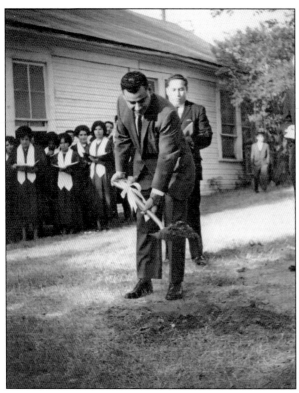

In 1966, the congregation of Emanu-el United Methodist Church broke ground on their new building. This picture captures the moment. (Courtesy of Casa Emanu-el United Methodist Church.)

By 1967, the members of Emanu-el United Methodist Church were placing a time capsule in the wall of their new building on Akard Street in Little Mexico. Despite Little Mexico's declining population, the church had decided to stay in the old barrio, while most other congregations were moving away. (Courtesy of Casa Emanu-el United Methodist Church.)

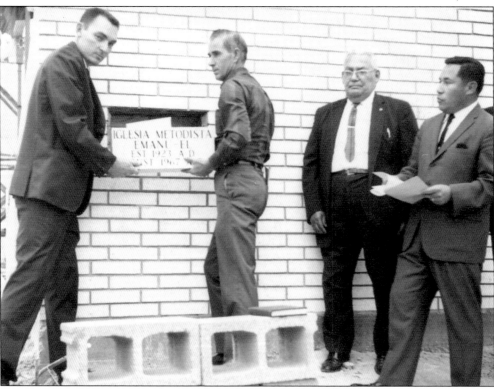

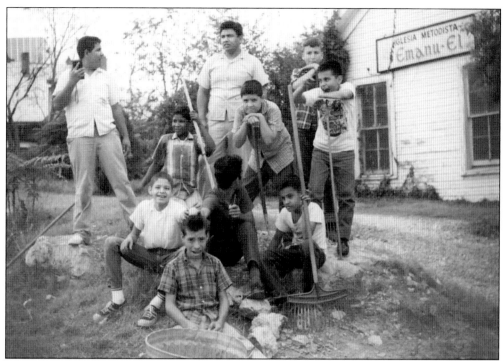

Little Mexico's churches often sponsored neighborhood clean-ups. Here, in this 1963 photograph, the boys of Emanu-el United Methodist Church take up rakes and brooms in the nearby streets and yards. (Courtesy of Casa Emanu-el United Methodist Church.)

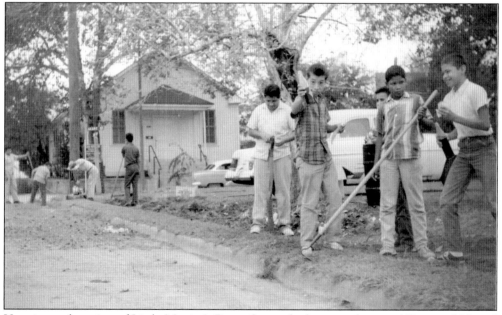

Here is another view of Little Mexico's Payne Street, looking north toward Emanu-el United Methodist Church in 1963. Slowly the neighborhood was changing, becoming less residential and more commercial. In a few short years, scenes such as this would be no more. (Courtesy of Casa Emanu-el United Methodist Church.)

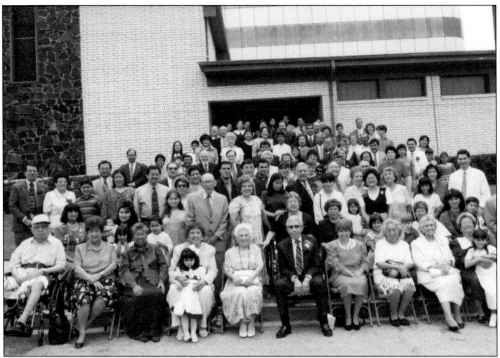

This photograph from 1996 shows the congregation of the Emanu-el United Methodist Church in front of its second building on Akard Street. Visible in the background is one of the massive high-rise office buildings encroaching on the old barrio. In a few years, without adequate parking and continuing pressure from its commercial neighbors and developers, the congregation was forced to move from Little Mexico, which it had called home for nearly a century. (Courtesy of Casa Emanu-el United Methodist Church.)

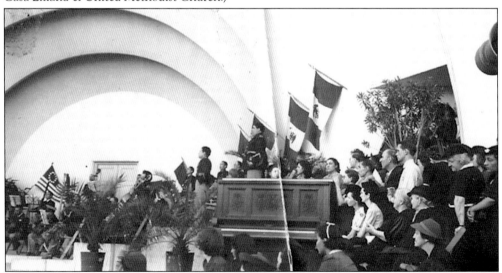

Dallas hosted the Texas Centennial at its state fairgrounds in 1936. For the celebrations, the city built several significant art deco structures, including a band shell performing stage. This photograph shows a program highlighting Texas's longstanding connection to Mexico and the Mexican people's contributions to the United States. (Courtesy of Dallas Mexican American Historical League.)

Like most Dallas residents, folks in Little Mexico flocked to the 1936 Centennial State Fair of Texas. Here an unidentified resident of Little Mexico poses on one of the art deco buildings at the fair. (Courtesy of Dallas Mexican American Historical League.)

The State Fair of Texas has always been a youth favorite. The 1936 Centennial State Fair was no exception. Pictured here from left to right, Little Mexico dwellers Mari Luisa Hernandez, Julia Rodriguez, Maimi Saucedo, Joaquin Medrano, and Frances Miramontes check out the latest cars at the 1936 State Fair of Texas. (Courtesy of Dallas Mexican American Historical League.)

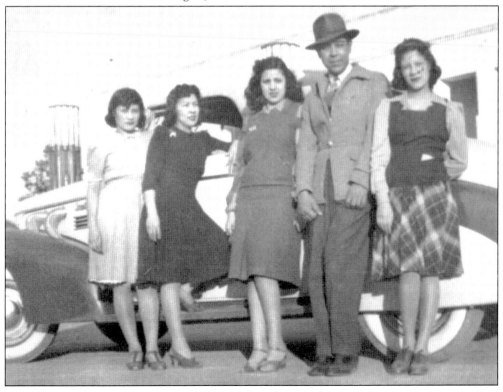

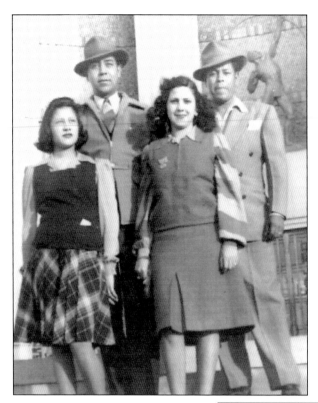

Little Mexico's Frances Miramontes, Joaquin Medrano, Maimi Saucedo, and an unidentified man are shown in front of the Hall of State at the 1936 State Fair of Texas. (Courtesy of Dallas Mexican American Historical League.)

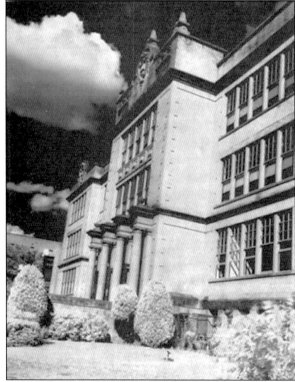

Crozier Tech High School, located on Bryan and Pearl Streets, was the main Hispanic public high school during the 1950s. This photograph of the school dates from that period. (Courtesy of Dallas Mexican American Historical League.)

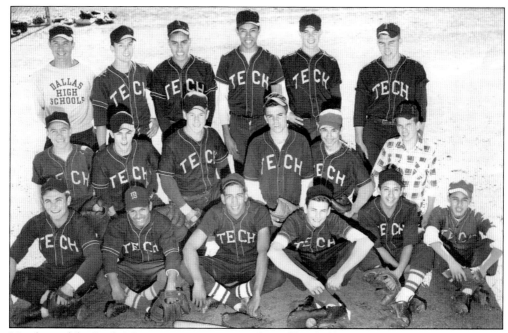

Members of the Little Mexico community were fans of baseball; it was a passion that was passed on through several generations. This 1950s picture shows one of Crozier Tech's winning baseball teams. (Courtesy of Dallas Mexican American Historical League.)

Another winning Crozier Tech baseball team poses for the camera in the 1950s. (Courtesy of Dallas Mexican American Historical League.)

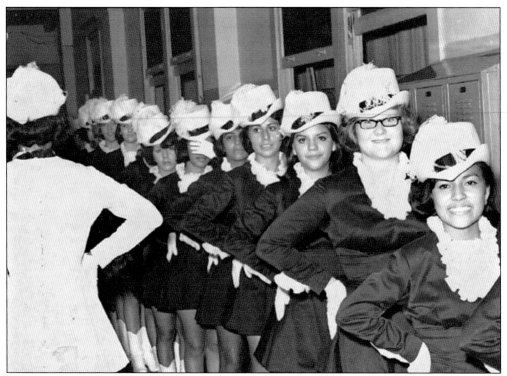

In the 1950s, members of the Crozier Tech drill team smile as they prepare to perform. (Courtesy of Dallas Mexican American Historical League.)

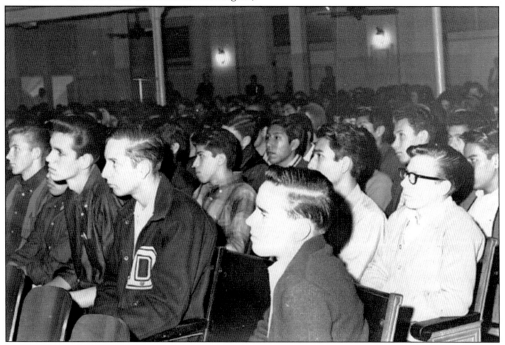

Students at Crozier Tech High School sit attentively during a function in the school's auditorium in the 1950s. (Courtesy of Dallas Mexican American Historical League.)

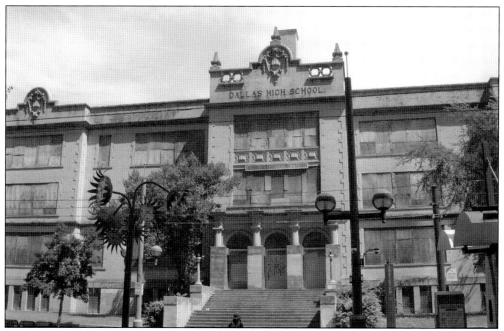

The Dallas Independent School District sold the property and buildings of Crozier Tech to private investors in 1998. Since then, the old school has sat vacant and shuttered, slowly decaying in the center of downtown Dallas. This photograph shows the only remaining Tech Building today. (Author's collection.)

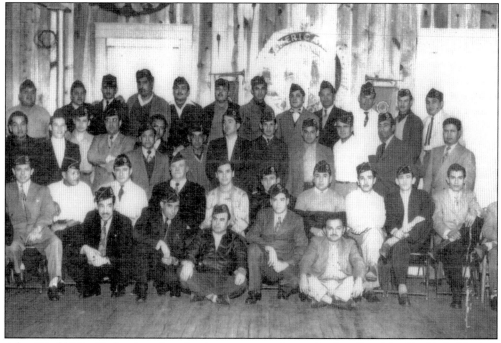

After World War II, the American Legion, a veterans' organization, flourished in Little Mexico. This post-war photograph shows the Legion's members in the barrio. (Courtesy of Dallas Mexican American Historical League.)

This 1950s picture shows the American Legion post in Little Mexico. (Courtesy of Dallas Mexican American Historical League.)

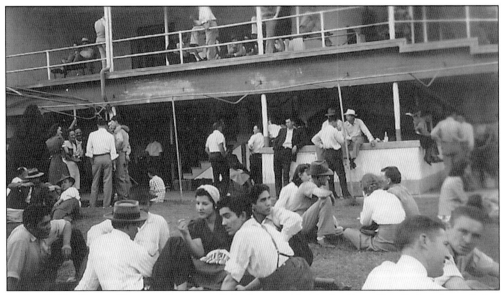

In the 1940s, Henry Chavoya (foreground) is shown with his family at Fair Park prior to being sent off to war. (Courtesy of Juanita Chavoya Nanez.)

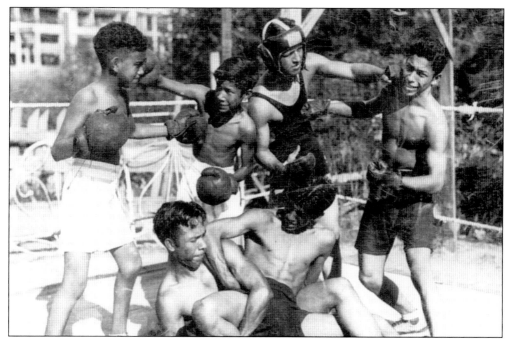

Boxing was another favorite sport of Little Mexico. This photograph of a youth boxing club was taken in the 1920s at the Mexican Park on Akard Street, near Caruth Street. Eventually, the Golden Gloves organization recognized the talent of many of Little Mexico's young men and became a major sponsor of youth boxing activities in Little Mexico. (Courtesy of Dallas Mexican American Historical League.)

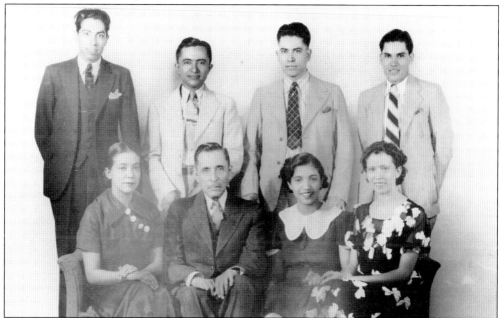

By 1937, the Villasana family had established several businesses that catered to the neighborhood. Pictured are, from left to right, (first row) Refugio "Cuca," Constantino, Ofilia, and Maria; (second row) Arturo, Constantino II, Rodolfo, and Louis. (Author's collection.)

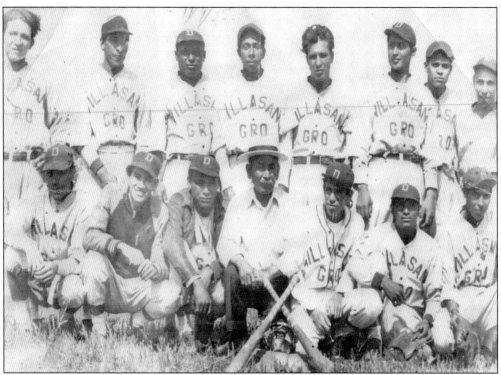

Little Mexico businesses often sponsored neighborhood athletic teams. This 1935 photograph shows the members of the Villasana Grocery Store's baseball team. Standing, third from right, is team member Pete G. Rojo. (Courtesy of Dallas Mexican American Historical League.)

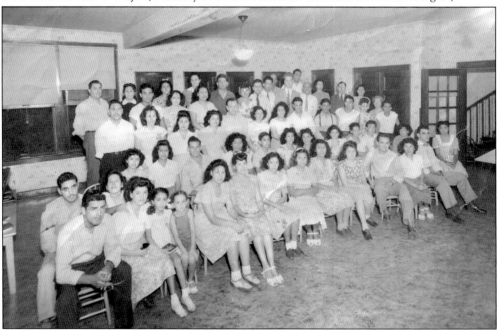

Hispanic Methodist youth enjoy the comforts of the Wesley Center in Little Mexico in 1944. (Courtesy of Casa Emanu-el United Methodist Church.)

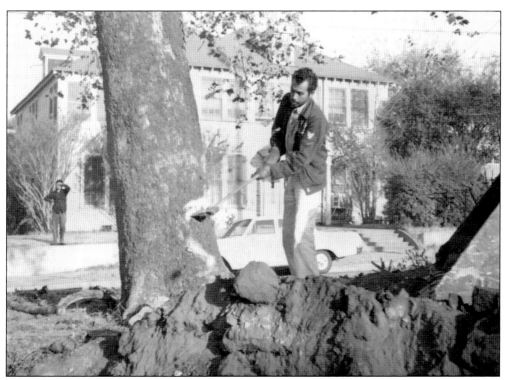

This 1945 photograph shows Little Mexico's Wesley Center at Moody and Akard Streets. (Courtesy of Casa Emanu-el United Methodist Church.)

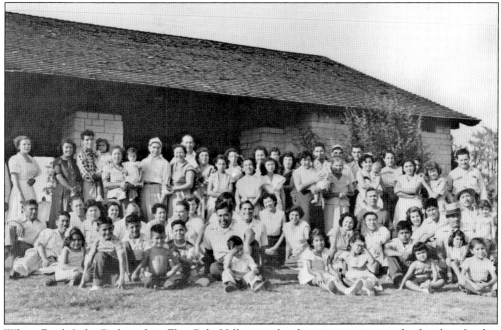

White Rock Lake Park and its Flag Pole Hill were also favorite picnic sites for families. In this early 1950s photograph, several families, including the Martinezes and Herreras, enjoy White Rock's picnic area. (Courtesy of Rene Martinez.)

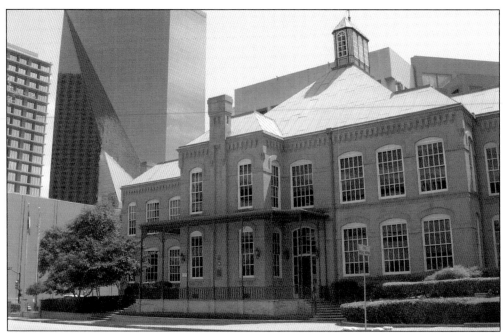

Cumberland Hill Elementary School was one of Dallas's first brick public school buildings. The Cumberland Hill Presbyterian Church had used the site on Akard Street as a school prior to the Civil War. The structure, dating from the late 1890s, was, by the 20th century, one of the primary public elementary schools for Little Mexico's children. The building was renovated into an adaptive reuse project in the 1980s and now serves as offices for an oil company. Prior to that, the former governor of Texas, William Clements, changed the building in the late 1970s to accommodate the headquarters of his drilling services company, SEDCO. It stands as one of the few examples of a brick public school in Dallas County dating from the 19th century. It is one of the earliest examples of an adaptive reuse project in the city of Dallas. Generally, 19th-century buildings were torn down in Dallas, but this structure was saved. This photograph shows the building today. (Author's collection.)

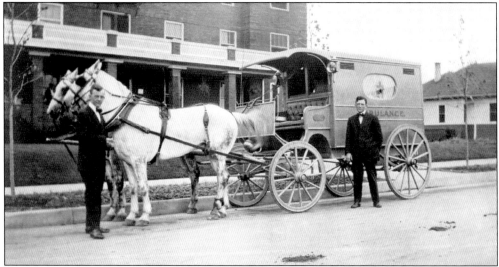

In 1914, when this photograph was taken, motorized vehicles were still somewhat novel in Dallas. The image shows a horse-drawn ambulance outside Parkland Hospital. (Courtesy of Crow Holdings.).

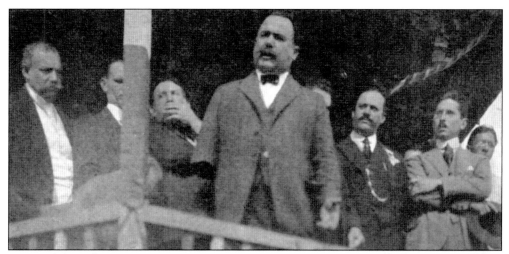

Mexico did not forget its expatriate citizens after their exodus during and after the revolution. In 1921, former revolutionary general and Mexican president Alvaro Obregon visited Dallas's Mexican Park in Little Mexico. The small park, now the site of the Fairmount Hotel, was on the corner of Akard and Caruth Streets. Obregon, with the one arm, is seen in this photograph delivering a speech at the park with Texas governor William Hobby at far left. Obregon would joke that he was elected because the people knew he had only one arm, and that because of that, he would steal less while in office. (Courtesy of the City of Dallas.)

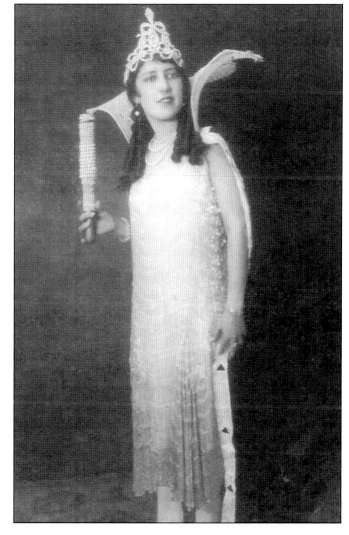

In 1928, Cipriana Villarreal was crowned queen at the Fiesta Patria at Pike Park on el Diez y Seis de Septiembre. Here she poses for her official photograph. (Courtesy of Dallas Mexican American Historical League.)

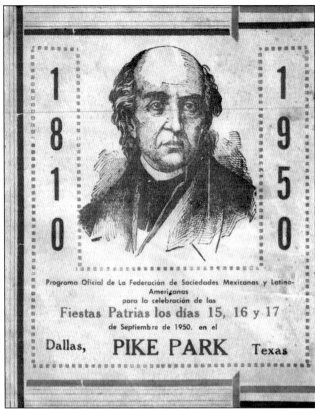

Programa Oficial de La Federación de Sociedades Mexicanas y Latino-Americanas
para la celebración de las
Fiestas Patrias los días 15, 16 y 17
de Septiembre de 1950. en el

Dallas, **PIKE PARK** Texas

The most important Mexican holiday celebrated in Little Mexico's Pike Park was, and continues to be, Mexico's Independence Day, el Diez y Seis de Septiembre. This is the cover for the official 1950 celebration program, sponsored by La Federacion de Sociedades Mexicanas y Latino-Americanas. The cover is a print of Fr. Miguel Hidalgo, a parish priest who was a leader in Mexico's independence movement of 1810. The program contained 10 pages of advertisements representing 41 businesses throughout Little Mexico. (Courtesy of the Mexican American Historical League.)

By 1966, when this picture was taken, Pike Park and its small recreation center had been reduced through street widening and other "improvements." (Courtesy of Casa Emanu-el United Methodist Church.)

The ballroom adjacent to the El Fenix Restaurant on McKinney Street was a popular nightspot for Little Mexico's party people. This 1938 photograph shows the ballroom's dance floor and murals. (Courtesy of the Firebird Group.)

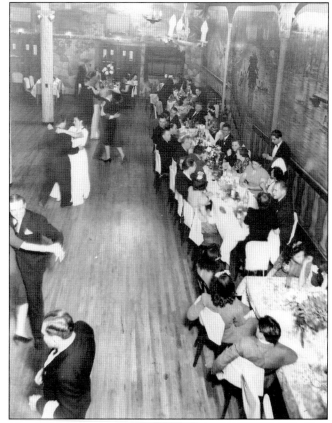

The Marceliño Marceleno Band was one of Dallas's favorite musical combos in the 1950s. Here the band performs at Arlington House at Lee Park, on the northern edge of Little Mexico. (Courtesy of Celeste Guererro.)

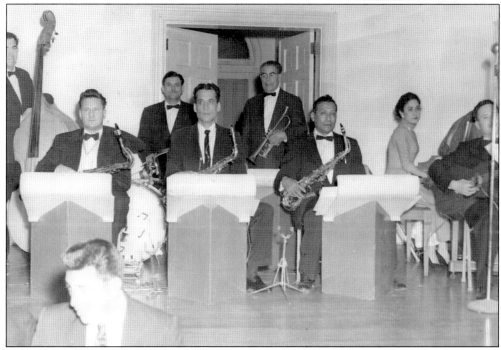

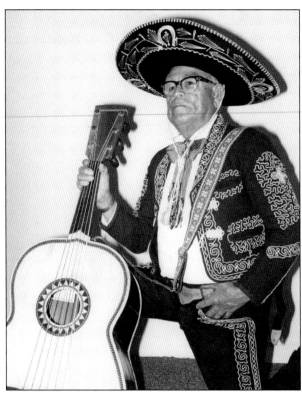

Shown here in 1969, Paul Guererro Sr. was a fine musician who was well known by residents of Little Mexico. Though dressed in charro attire, Paul was actually a big band musician. (Courtesy of Celeste Guererro.)

Alfredo Casarez and Paul Guererro Sr. perform at the State Fair of Texas in 1946. (Courtesy of Celeste Guererro.)

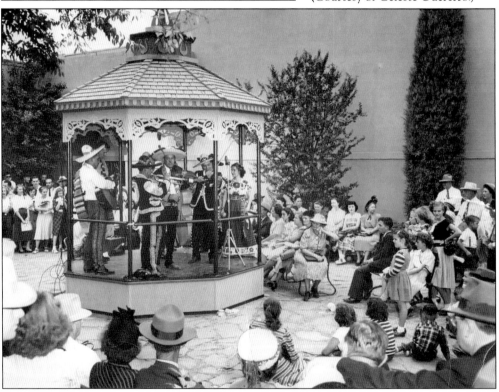

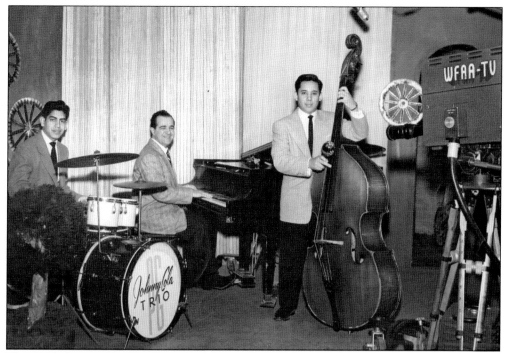

This 1950 photograph was taken inside the studios of WFAA-TV in Dallas. It shows the members of the Johnny Colo Trio. Pictured are, from left to right, Paul Guererro Jr., drums; Johnny Colo, piano; and Al Wesar, bass. (Courtesy of Celeste Guererro.)

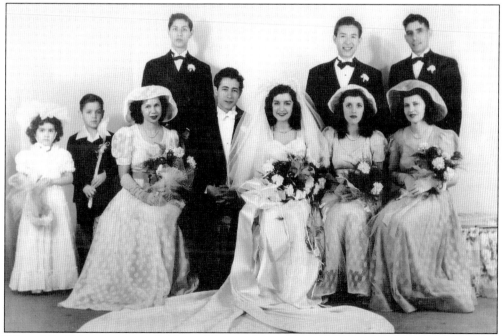

When Alfred Martinez, a son of Mike and Faustina Martinez, the founders of the El Fenix Restaurants, returned from serving in World War II, he married the young, beautiful Anita Nanez. This 1946 picture shows them and their wedding party. (Courtesy of Anita N. Martinez family archive.)

Carmen Vasquez, seen here on Elm Street in downtown Dallas in 1936, would soon marry Anita Nanez Martinez's brother Joe Nanez. Joe died in combat in France in 1944. (Courtesy of Juanita Chavoya Nanez.)

An unidentified photographer took this picture of Louis Villasana at the same spot on Elm Street. The Villasanas owned several businesses in Little Mexico. This photograph dates from 1935 and shows, in the background, one of Dallas's most historic still-standing buildings, the Wilson Building. (Author's collection.)

Three

ECONOMIC STRUCTURE
FROM FAMILY SHOPS TO CORPORATIONS

Work was hard to find for the first Mexicans in Dallas. As now, racial prejudices limited economic opportunity for Hispanics. The jobs that existed were hard and dirty, with little or no worker protection like unions. While the 1930s saw a rise in union activity in Little Mexico, just like the entire country did, employers resisted organizing efforts. Most residents arrived from Mexico with just the clothes on their back.

Not unlike today, employment agencies, both formal and informal, trafficked in cheap labor. Agricultural workers would be picked up in Little Mexico by crews for backbreaking work in the fields of Garland or northwest Dallas. There was so much agricultural work that a smaller barrio, El Ranchito (The Little Ranch), developed northwest of Little Mexico.

Many residents found steady employment in the city's small but growing service sector. Many early Mexican cooks and waiters got their start at hotels like the Oriental, Adolphus, Baker, and Stoneleigh. Eventually, many opened their own small cafés in the barrio.

Other large, labor-intensive businesses were dependable employers. Lone Star Cement, Continental Gin, Dallas Foundry, and the Parkland and St. Paul hospitals provided hard work with small, but regular, paychecks. Very few young and physically fit residents of Little Mexico were able to escape working at the meat packing plants of Neuoff or Hormel.

However, entrepreneurship proved to be Little Mexico's lasting legacy. Small family-run businesses sprang up all over the neighborhood. Bakeries and food stores (often combined) seemed to be on every corner. Tortilla factories followed suit, especially when the product found a market outside the barrio. Beauty shops, taverns, funeral homes, and even the ubiquitous insurance salesmen were soon plying their trades all over Little Mexico. Businesses such as El Poblano Café, La Colonial Bakery, Zambrano Photography Studio, Mendoza Cleaners, Texas Tortilla Factory, Reyes Grocery, Zuniga's Market, Cortez Funeral Home, Hernandez Grocery, Nena's Beauty Shop, Valdez Jewelry Store, Lena's Flowers, Mexico City Café, and Brantley's Bowling Alley flourished in Little Mexico around the 1950s.

Most family-owned businesses were fated to a generation or two of mild success, but one industry, the food trades, was to transform the family shop into the corporate age. Many small family cafés multiplied into chains. Oftentimes, after decades of success, they were able to sell their corporations. Whatever the small businesses' fate, they provided the bases for the next generation's better education and lifestyle.

Out of that first generation of entrepreneurial success in Little Mexico came many of Dallas's early professional class of doctors, lawyers, architects, and the like. Without the sacrifice, hard work, and perseverance of Little Mexico's first businessmen and women, the prominence of today's Dallas Mexican American community would not exist.

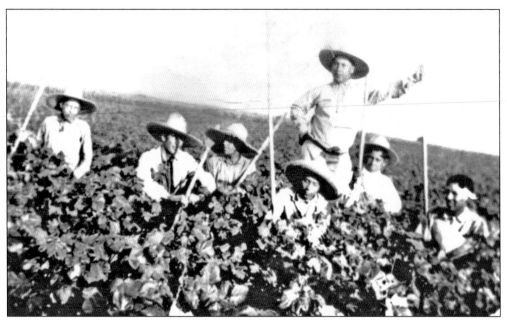

Shown here in 1913 are, from left to right, (sitting) Gilbert, Frank, Alfred, Mack, Willie Jack, and Jim Cuellar. Standing is Amos Cuellar. This photograph was taken at the Cuellars' farm near Kaufman, just southeast of Dallas. (Courtesy of Cuellar Family Archives.)

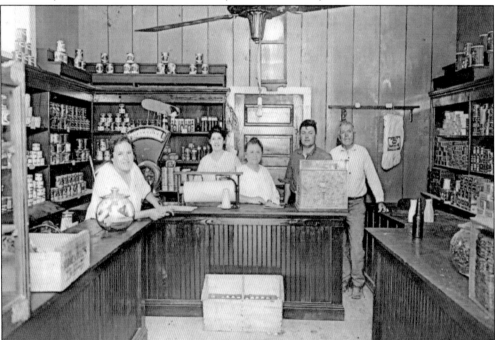

The Mongoras Grocery and Market at 2606 Caroline Street was one of the oldest businesses in Little Mexico. This 1919 photograph shows the Mongoras family inside their store. Pictured are, from left to right, Anita, Beatrice, Tomasita, and Frank Mongoras and an unidentified gentleman. Frank ran the store, aided by his wife Beatrice and his sister Anita. (Courtesy of Anita N. Martinez family archives.)

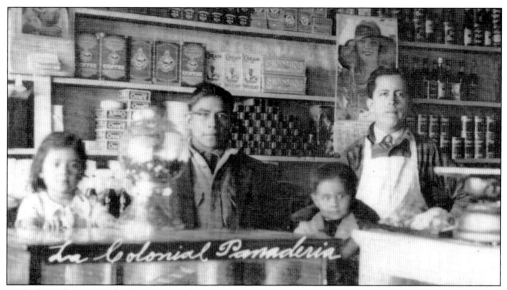

La Colonial Store and Bakery (*panaderia*) was located at 2408 North Akard Street. Ramon Alonzo founded the famous bakery known for its *pan dulce* (sweet bread). Along with Ramon (standing between the children) in this 1930 photograph of the bakery's interior is his daughter Carmen and son Martin. Martin went on to serve his country in the Korean War. He eventually opened his own popular bakery in the Bachman Lake area of Dallas. Also in the photograph, at right, is Jesse Alonzo. To this day, the Alonzo family owns and operates bakeries in Dallas. (Courtesy of the Dallas Mexican American Historical League.)

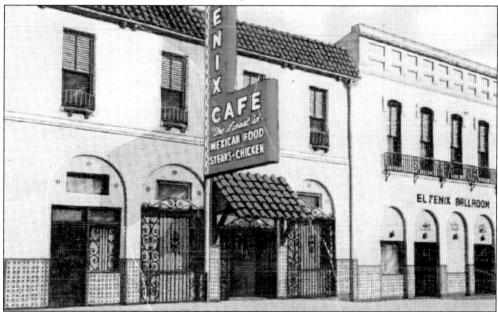

In 1918, Mike Martinez, who had started by washing dishes at Dallas's Oriental Hotel, opened his first café on the corner of Griffin Street and McKinney Avenue in Little Mexico. His new restaurant was named El Fenix. He married Faustina Porras, and they had several children who helped grow the El Fenix chain. This photograph shows the original El Fenix at 1608 McKinney Avenue in 1940. (Courtesy of Firebird Group.)

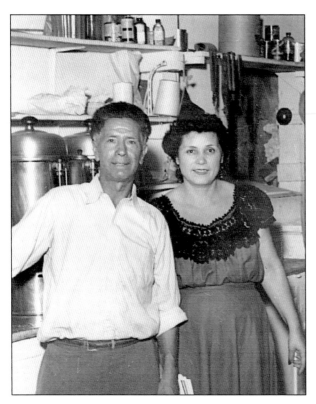

This 1950 photograph shows Mike and Faustina Martinez inside the kitchen of their El Fenix restaurant on McKinney Avenue. (Courtesy of Anita N. Martinez family archive.)

Maria Luna, a widow who had been in the United States for less than one year, established Luna's Tortilla Factory in February 1924. Her shop at 2209 Caroline Street was in an old two-story building. Her children, Carmen and Francisco, lived with their mother above the factory. She needed the expertise of the Mexican women of Little Mexico to make the tortillas, but they were often reluctant to work outside their homes. So Maria took the tortilla ingredients to the women's homes and then picked up the finished tortillas for baking at her factory. By 1938, she had outgrown the old factory and built a new one at 1615 McKinney Avenue. The building still stands today and is landmarked. This photograph from the 1950s shows her son, Fransisco "Pancho," and his wife Alejandra. (Courtesy of Dallas Mexican Historical League.)

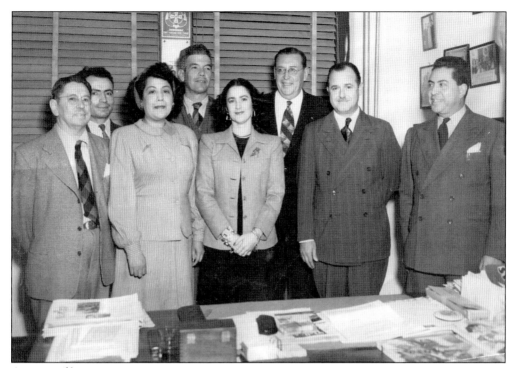

A group of businessmen and women of Little Mexico founded the Dallas Mexican Chamber of Commerce in the early 1930s. This photograph, from about 1948, shows members from the Chamber's Board of Directors. Pictured are, from left to right, J. Hinojosa, unidentified, Mrs. Paredes, Joe Rodriguez, two unidentified, Dr. Julian T. Saldivar, and Rodolfo Villasana. (Courtesy of Dolores Saldivar Brown.)

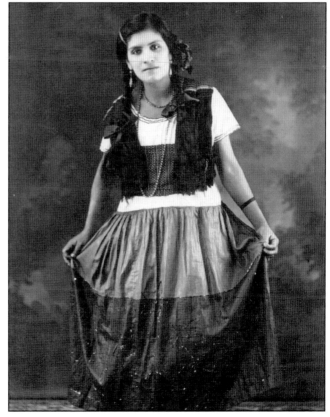

Founder of Luna Tortilla Factory, Maria Luna's sister Casimira Luna Valdez is seen in this 1920s photograph. She had opened her own café, El Original, next to the Luna Tortilla Factory on McKinney Avenue. (Courtesy of Mercedes Olivera.)

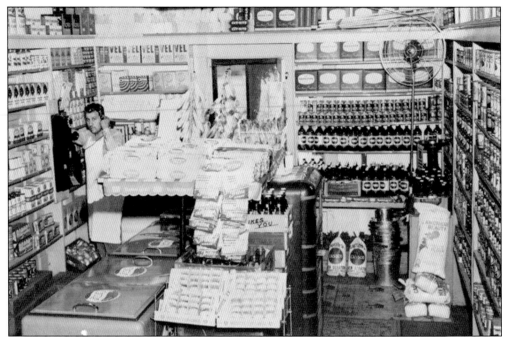

The Olivera Grocery Store was located on upper North Harwood Street in Little Mexico. This 1950 photograph shows the store's interior. (Courtesy of Dallas Mexican American Historical League.)

As a way to make a living, Elvira Leal opened a small tortilla factory, Dallas Tortillas Company, while her husband, Ruben Leal, was away during World War II. When Ruben returned from the war, the Dallas Tortilla Company, located on North Harwood Street, prospered. This 1960s photograph shows the store's modest exterior. (Courtesy of Dallas Mexican American Historical League.)

Stados Tortilla Factory was also located on North Harwood Street. Its building is seen in this 1955 photograph. (Courtesy of Dallas Mexican American Historical League.)

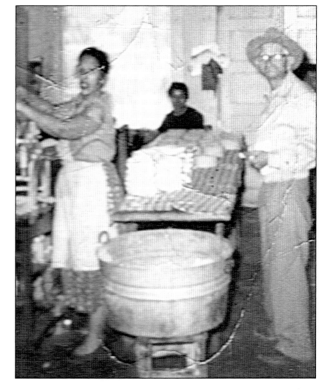

This 1955 picture shows Elvira and Ruben Leal, founders of Dallas Tortilla Factory, working inside the kitchen of their shop. Their children still operate several Dallas Tortilla stores. (Courtesy of Dallas Mexican American Historical League.)

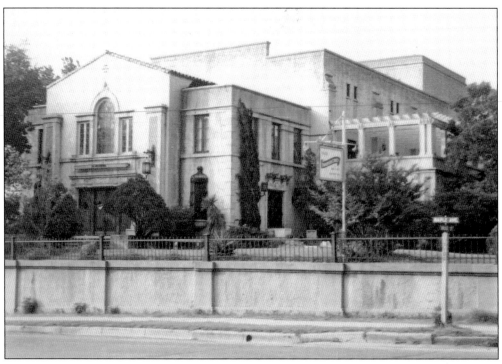

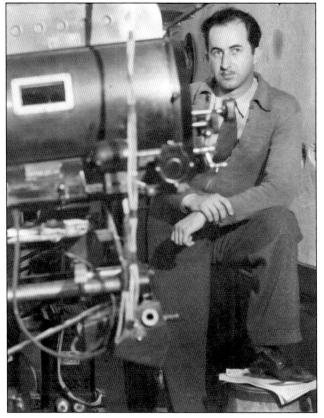

Joaquin Jose "J. J." Rodriguez ran a small movie house near downtown Dallas called Azteca Movie House. In the early 1940s, he purchased the Dallas Little Theater Building, located on Maple Avenue in Little Mexico. Seeing the need and opportunity for movies in Spanish, he turned the theater house into Theatro Pan Americano. This photograph of the theater dates from about 1950. (Courtesy of Mariangel Rodriguez.)

This picture shows J. J. Rodriguez inside the projection room of the Theatro Pan Americano during the 1950s. Initially, to interest Little Mexico's residents in his movies, he would drive around the neighborhood in his car offering families rides and free admission to the theater. (Courtesy of Mariangel Rodriguez.)

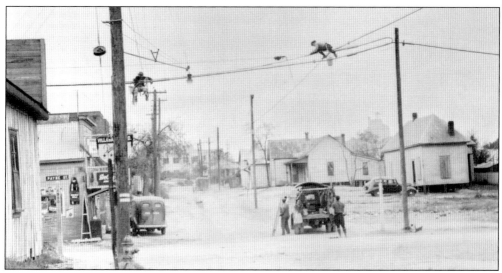

Street and power line improvements caused city crews to snap this photograph at the corner of Turney and Payne Streets in 1940. The view is south along Turney Street, toward downtown. Like all roads in Little Mexico at the time, Turney was unpaved. At left, in the background, can be seen the brick facade of the St. Ann's School. In the foreground, on the left corner, is the Villasana Food Store, located at 2616 Turney. Rodolfo Villasana founded it in 1932. To the right on the horizon is the faint outline of the 29-story Magnolia Oil Building, with its huge, neon Flying Red Horse or Pegasus. Built in 1922, the building was, for years, one of the tallest structures west of the Mississippi River. The Flying Red Horse has become a symbol of Dallas. The Villasana Food Store functions to this day in Little Mexico. (Courtesy of the Dallas Historical Society.)

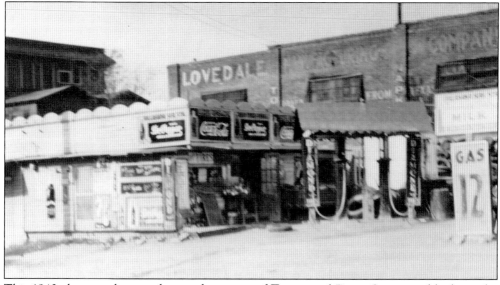

This 1940 photograph was taken at the corner of Turney and Payne Streets and looks to the northwest. It illustrates the varied building types found in Little Mexico at the time. In the foreground is the wood-framed Villasana Service Station, part of several Villasana family-owned businesses. Behind the service station is a large home used as the American Legion lodge. Also visible are brick manufacturing and warehouse buildings, evidencing the area's industrial nature. (Courtesy of the Dallas Historical Society.)

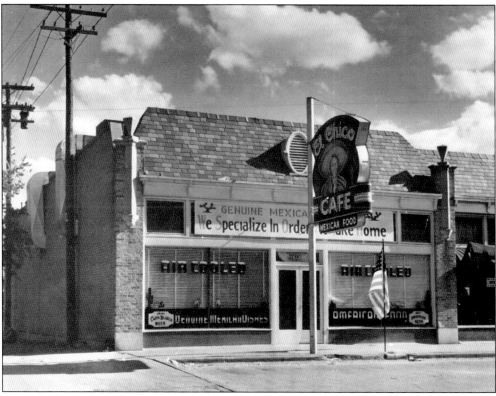

Adelaida Cuellar began making tamales for the Kaufman County Fair during the 1920s. She soon realized that she was bringing in more money during those few weeks than the family was making through their ranching efforts. In the 1940s, she, her husband, and her sons opened the first El Chico Café. This 1950s photograph shows the original El Chico Café on Oak Lawn Avenue, near the intersection of Lemmon Avenue. (Courtesy of Cuellar Family Archives.)

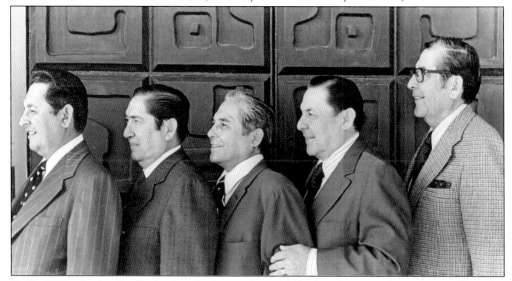

By the 1960s, the five Cuellar brothers had opened several El Chico locations throughout Dallas. This photograph, from that same period, shows the brothers. (Courtesy of Cuellar Family Archives.)

This photograph shows Adelaida Cuellar and her husband cutting the cake at their 60th wedding anniversary in 1951. (Courtesy of Cuellar Family Archives.)

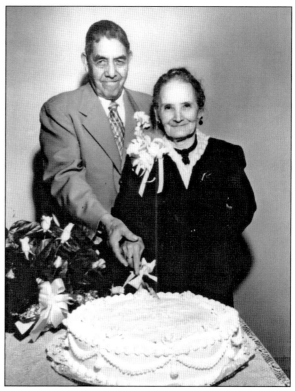

This photograph is of the Cuellar family in the 1950s. (Courtesy of Cuellar Family Archives.)

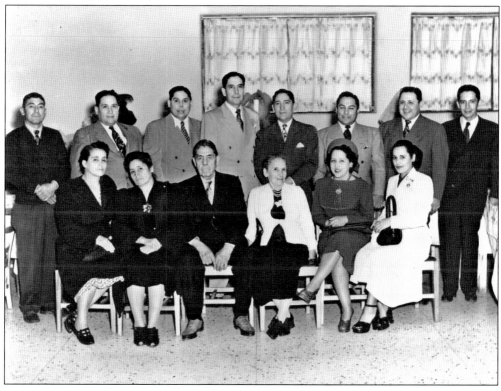

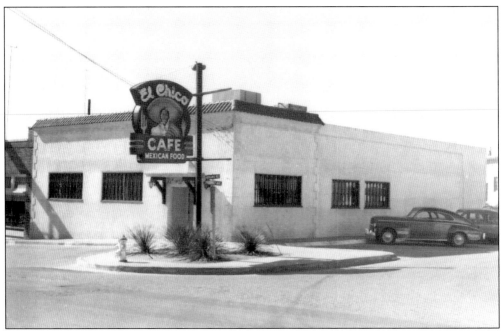

The second El Chico restaurant was located in the Lakewood section of Dallas. This photograph shows the exterior, as it was in the mid-1950s. (Courtesy of Cuellar Family Archives.)

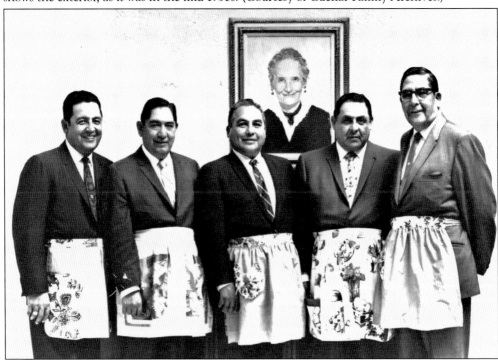

One of the most popular promotions that were used by the Cuellar brothers for their chain of El Chico restaurants was an advertisement campaign premised on the fact that their mother had been the prime mover of their business. This 1960s photo was utilized in the ad campaign "Like mother, like sons." (Courtesy of Cuellar Family Archives.)

Mack Cuellar is shown with two of his brothers in this 1940s photograph. (Courtesy of Cuellar Family Archives.)

This 1950s photograph shows the interior of the original El Chico restaurant on Oak Lawn Avenue, on the northern edge of Little Mexico. (Courtesy of Cuellar Family Archives.)

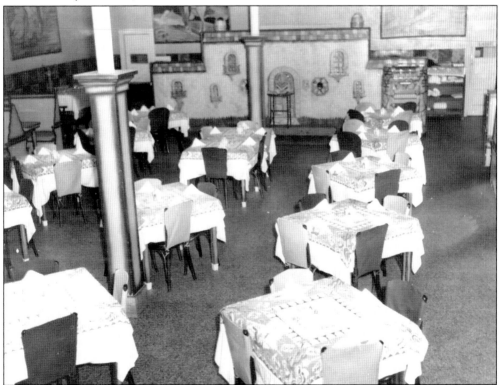

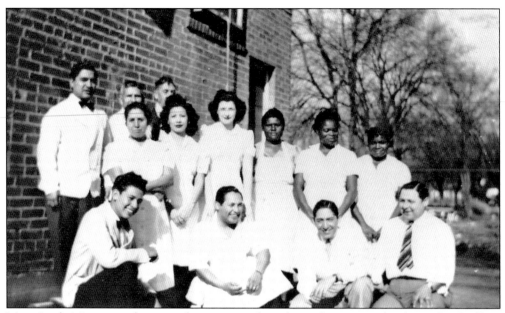

Many Little Mexico residents got their start in the culinary business with jobs in the Cuellars' El Chico restaurants. This 1950s photo shows the employees of the original El Chico posing for the camera behind the restaurant. (Courtesy of Cuellar Family Archives.)

This 1950s photograph shows El Chico employees posing on their prized car behind the original restaurant. (Courtesy of Cuellar Family Archives.)

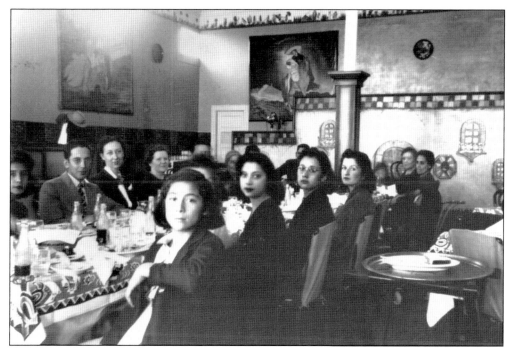

El Chico restaurants, though somewhat targeting an Anglo clientele, were also popular with Dallas's Mexican community. This 1940s photograph shows Mexican Americans enjoying the original El Chico's fine Tex-Mex food. (Courtesy of Cuellar Family Archives.)

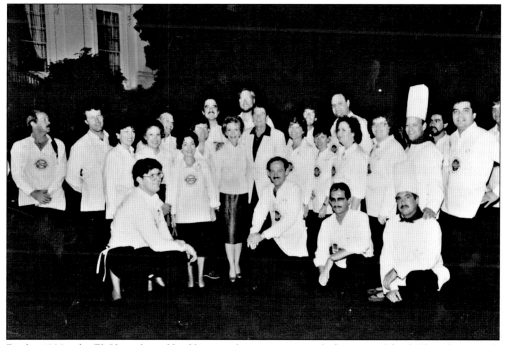

By the 1980s, the El Chico brand had become known nationwide for its good food. This photograph from 1985 shows El Chico employees catering a White House function for President Reagan and his wife, Nancy. (Courtesy of Cuellar Family Archives.)

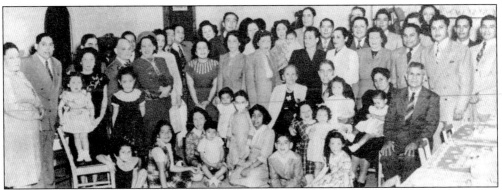

By Christmas 1949, when this photograph was taken, El Chico's Cuellar family had grown. This holiday picture shows four generations. (Courtesy of Cuellar Family Archives.)

J. J. Rodriguez married Maria "Angelita" de los Angeles in 1949. This is their wedding photograph. (Courtesy of Mariangel Rodriguez.)

Businessman J. J. Rodriguez and his wife, Angelita, are shown with Mercedes Olivera, far right, at a Cinco de Mayo celebration in the 1960s. (Courtesy of Mariangel Rodriguez.)

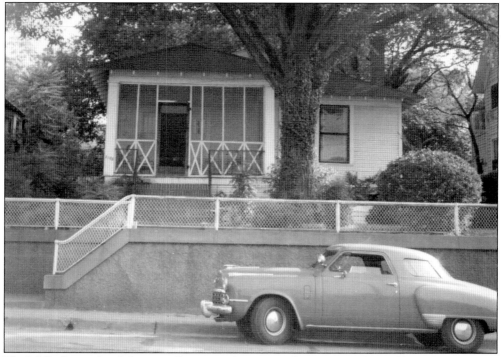

The J. J. Rodriguez family home on Fairmount Street in Little Mexico was located behind the Theatro Pan Americano. This picture dates from the early 1950s. (Courtesy of Mariangel Rodriguez.)

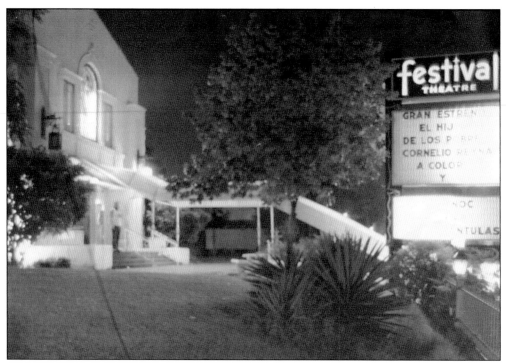

In 1962, J. J. Rodriguez changed the format of his movie house. Instead of solely Spanish movies, Rodriguez, with the encouragement of a New York promoter, started showing international and avant-garde films. The theater's terrace even offered fine dining. While the transformation was well received in reviews, Dallas was not ready for either international or avant-garde movies. From 1963 to 1983, Rodriguez reverted to the Spanish-language format and rechristened the theater Cine Festival. This 1970s photograph shows Cine Festival at its height. (Courtesy of Mariangel Rodriguez.)

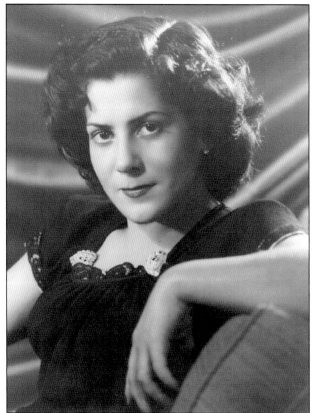

Maria "Angelita" de los Angeles, who married movie theater owner J. J. Rodriguez, could well have starred in movies herself. This is one of her 1940s portraits. (Courtesy of Mariangel Rodriguez.)

Theatro Pan Americano and Cine Festival were often used by local organizations for meetings and other special events. J. J. Rodriguez is seen in this 1950s photograph dressed in charro attire. (Courtesy of Mariangel Rodriguez.)

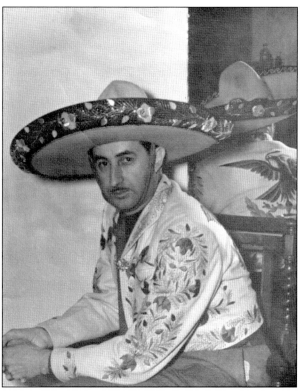

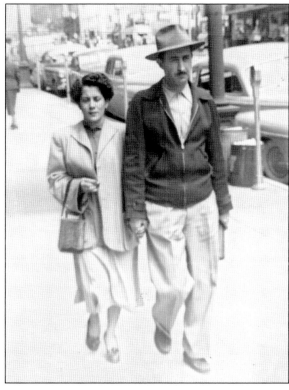

This 1940s photograph shows J. J. Rodriguez and his wife, Angelita, walking in downtown Dallas. (Courtesy of Mariangel Rodriguez.)

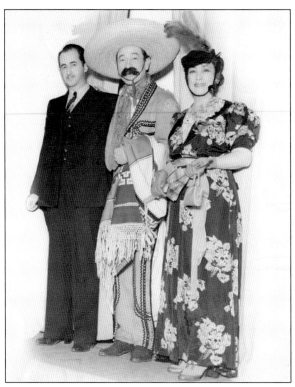

Part of the job of movie theater owners in the 1950s would be hosting actors at the opening of their films. This 1950s photograph shows J. J. Rodriguez with two unidentified Mexican actors in Dallas for the promotion of their film. (Courtesy of Mariangel Rodriguez.)

This 1983 photograph shows J. J. Rodriguez and his family at Cine Festival Theater. Pictured are, from left to right, (first row) J. J. Rodriguez, son David, Angelita, daughters Mariangel and Gloria, granddaughter Olivia, and Jesse and Elias Banavidez; (second row) sons Roland and J. J. Jr. (Courtesy of Mariangel Rodriguez.)

Theatro Pan Americano had a wonderful terrace, which is pictured in this winter scene from the mid-1950s. The theater's owner, J. J. Rodriguez, made a tradition of inviting Little Mexico's children to Christmas programs and films. While other kids played outside and watched movies, J. J.'s children were busy wrapping gifts for them to enjoy. This was an annual holiday tradition of generosity. (Courtesy of Mariangel Rodriguez.)

After 45 years in the movie theater business, J. J. Rodriguez finally closed Cine Festival in 1983. This photograph from the last night of the movie theater's existence poignantly illustrates the evening's mood. (Courtesy of Mariangel Rodriguez.)

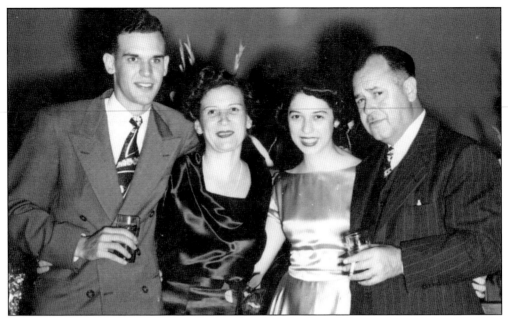

Pictured in this 1950s photograph is the Saldivar family. From left to right are Julian "Ted" Jr., Maria, Dolores, and Dr. Julian T. Saldivar. Aside from his invaluable service as a pediatrician to countless Little Mexico children, he also aided and encouraged Hispanic business growth in Dallas. (Courtesy of Dolores Saldivar Brown.)

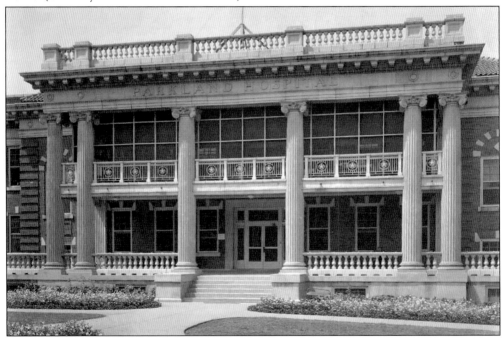

In 1894, Dallas County opened Parkland Hospital. The first building was a pavilion style frame structure. In 1913, a new brick building was opened. Many of Little Mexico's residents worked at the hospital and many more depended on it for their health care issues. This photograph shows the hospital's main façade in about 1930. (Courtesy of Crow Holdings.)

Four

BEGINNING OF THE END
WORLD WAR II AND URBAN RENEWAL

By the beginning of World War II, the face of Little Mexico was changing. The widening and paving of streets, the expansion of Love Field as a major airport (along with necessary routes to and from it), and a Depression-era interest in urban revitalization caused physical alterations. In 1935, the county's Relief Board produced a review of the city's "blighted" areas. In 1942, the Dallas Housing Authority created Little Mexico Village at the northern end of the barrio, the city's second public housing project.

The war itself changed the composition of Little Mexico. Young men went off to war, leaving behind aging parents and a fragile economic structure in the barrio. While the war economy created jobs in the defense industries, those jobs were not in the barrio. Moving away from Little Mexico proved more and more attractive.

Hundreds of Mexican American men and women from Little Mexico served their adopted country during the war. Many were not even citizens when they went off to fight. They returned from the war, if they were lucky, with a new sense of self. When they liberated Paris and the Philippines, they were greeted as simply Americans, not as second-class citizens. New organizations emerged in Little Mexico, such as the GI Forum and other veteran groups that fought against discrimination in employment, education, and housing.

Further, old farming towns around Dallas grew into suburbs like Carrollton, Grand Prairie, and Garland. Many young Mexican American families decided to buy their first GI Bill homes in these suburbs. Improved transportation infrastructure meant people did not need to live close to the central business district any longer, and Little Mexico, with its proximity to downtown, was seen as old and decaying. For their part, most of Little Mexico's residents could not understand this city's disparaging portrayal of their neighborhood. Houses, while old, had always been in good repair. Garden clubs competed for the most elaborate landscaping, even planting flowers in the Little Mexico Village Housing Project's public areas.

While the first generation of Little Mexico's residents aged, they held on and continued to prosper and enjoy the amenities of being close to family and old friends. The quality of public education also became an issue at this time. The old inner-city schools that had barely served the needs of children of Little Mexico decades before were now dismal, inadequate affairs. New parents in Little Mexico knew that only moving could provide better educational opportunities for their kids, and given the importance of education to Mexican American families, they began to think of moving.

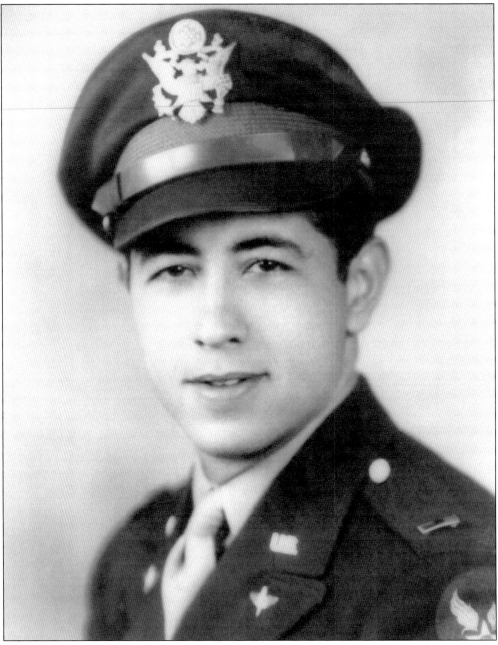

Alfred Martinez had grown up in his parents' El Fenix restaurant business in Little Mexico. By the end of World War II, he was piloting B-29 bombers for the U.S. Army Air Corp. This is a 1945 studio portrait of Lt. Alfred Martinez. (Courtesy of Anita N. Martinez Archive.)

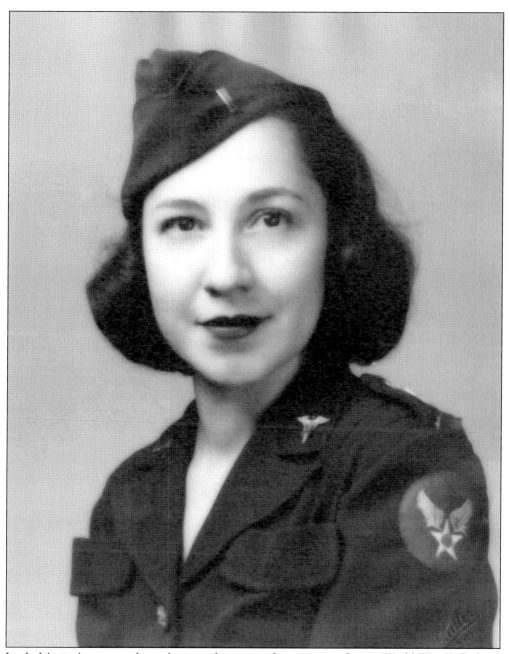

Little Mexico's women also volunteered to serve their country during World War II. Dolores Martinez was a young nurse when she joined the U.S. Army Air Corp. Dolores would make the military her career, retiring as a lieutenant colonel in the air force. This photograph shows Lt. Dolores Martinez in 1944. (Courtesy of Rene Martinez.)

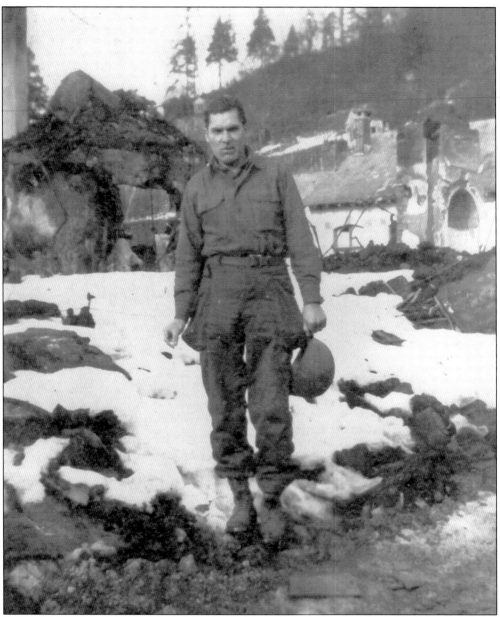

World War II saw hundreds of Little Mexico's sons and daughters serve their adopted country. This photograph was taken in late December 1944 in Malmedy, Belgium, during the Battle of the Bulge. It shows Pfc. Louis Villasana, Medical Aidman, 423rd Medical Collecting Company, U.S. Army. Villasana sent the snapshot to his sister, Refugio "Cuca" Verver, who was back home in Little Mexico. On the back of the photograph, Villasana wrote that it had been taken the day after American forces had recaptured the town from the Germans. He noted that the ruins in the background had been, before the fighting, a church. As a combat medic, Private First Class Villasana was keenly aware of the human damage caused by the war. During the six weeks of combat at the Battle of the Bulge, 81,000 Americans were wounded and 19,000 killed. Villasana survived the war, was awarded the Bronze Star for his service, and returned home to Dallas. He died in 2003; he was 92 years old. (Author's collection.)

Pvt. Alberto Gonzalez poses in his army uniform in this 1945 photograph with his wife, Paula. After the war, Alberto would be involved in several businesses. He was the first Hispanic cab driver in Dallas and the first Latino manager of a major insurance company in the city. Eventually, he opened Gonzalez Funeral Homes, which his sons manage to this day. (Courtesy of Albert Gonzalez.)

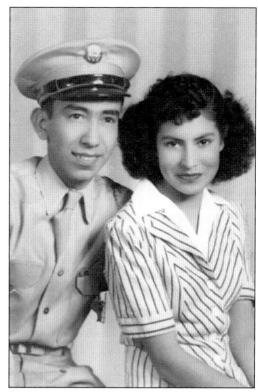

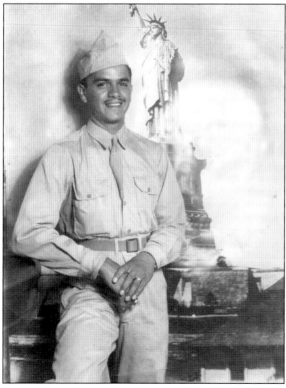

Joe M. Nanez was an active, handsome lad who grew up in Little Mexico. In the early 1930s, he was a member of the first Boy Scout troop in Little Mexico, El Exploradores. His mother, Anita, operated one of Little Mexico's first beauty shops. Joe's younger sister, Anita Nanez Martinez, would eventually become Dallas's first Hispanic city council member. This photograph was taken in 1944 in New York City just before Joe shipped out to the European theater of war. Pvt. Joe Nanez, of the U.S. Army's 26th Division, was killed in action in France on November 12, 1944. (Courtesy of Juanita Chavoya Nanez.)

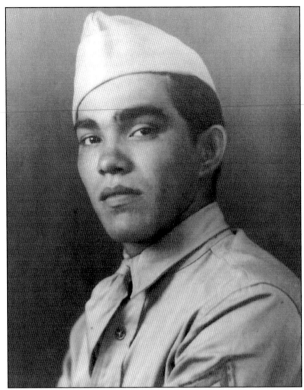

Tereso and Juanita Chavoya lived at 2805 Carlisle Street, on the northern border of Little Mexico. All four of their sons went off to fight for their country during World War II. This picture shows Staff Sgt. Henry Chavoya, of the U.S. Army Air Force, in about 1943. Late in the war, Henry ran into his younger brother, Cpl. Rudolph Chavoya, also in the U.S. Army Air Force, in Italy. The brothers had not seen each other in nearly two years. (Courtesy of Juanita Chavoya Nanez.)

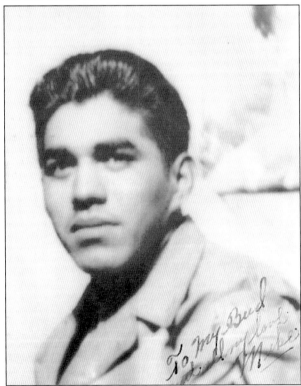

The Chavoyas' son, Mike Chavoya, is pictured in this wartime photograph. Private Chavoya served in the U.S. Army Air Force during World War II. (Courtesy of Juanita Chavoya Nanez.)

Pfc. Robert Chavoya of the U.S. Army Air Force poses here in front of military barracks stateside before his deployment overseas during World War II. (Courtesy of Juanita Chavoya Nanez.)

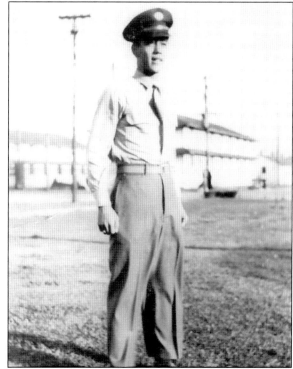

Lt. Alfred Martinez, U.S. Army Air Force, poses with his fiancé, Anita Nanez, in this 1944 photograph. (Courtesy of Anita N. Martinez Archive.)

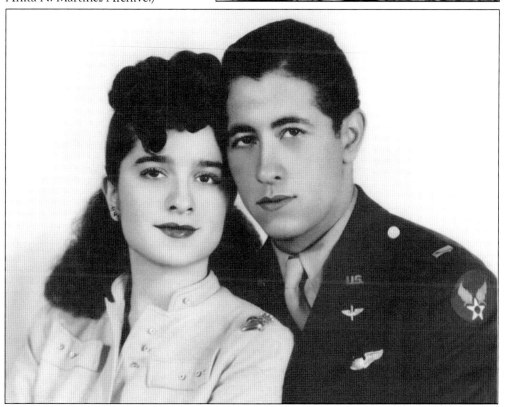

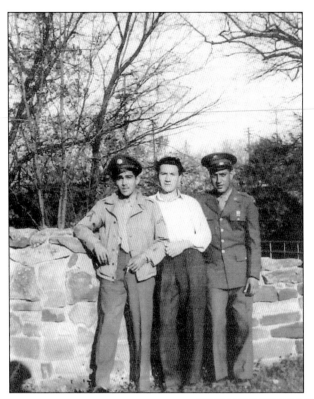

After returning from World War II, Little Mexico's veterans were eager to put the war behind them. In this snapshot from 1946 are, from left to right, Robert Flores, unidentified, and Henry Chavoya relaxing at Reverchon Park. (Courtesy of Juanita Chavoya Nanez.)

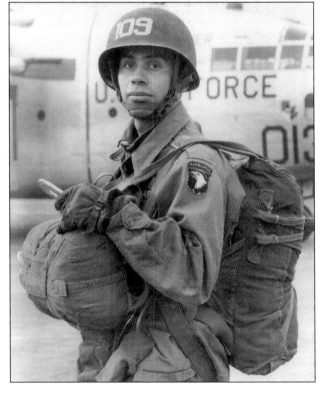

Joe Alvarez grew up on Bookout Street and attended St. Ann's School in Little Mexico. While too young to see combat in World War II, after the war, Joe became a paratrooper in the army's storied 101st Airborne Division (the "Screaming Eagles"). This photograph dates from the 1950s and shows Pfc. Joe Alavarez in full jump gear. (Courtesy of Joe Alvarez.)

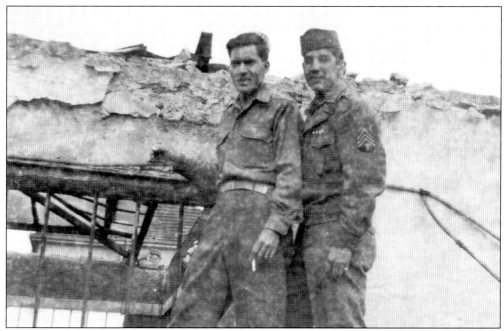

War often creates lifelong friendships, forged during great battles. Army Sgt Ignacio "Nacho" Diaz, right, and Pfc. Louis Villasana knew each other in Little Mexico before the war, but serving in combat together in Europe solidified their long friendship. Louis and Nacho are seen in this picture from 1945 in what is left of Giessen, Germany. (Author's collection.)

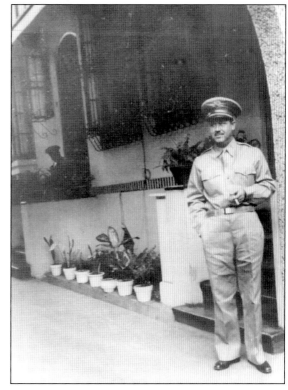

Dr. Julian T. Saldivar was born in San Antonio, Texas, and grew up in the Rio Grande Valley of South Texas. He attended Baylor College of Medicine in Dallas in the 1930s, waiting tables on the side at the El Fenix Café in Little Mexico. After receiving his medical training, he enlisted in the U.S. Army Medical Corps. This photograph shows Saldivar as a young officer in the Philippines, where he was stationed, in 1941. In spring 1942, the Japanese, after a long siege, captured the U.S. stronghold at Corregidor in the Philippines. Thousands of American troops, including Dr. Saldivar, were forced by their Japanese captors to march hundreds of miles in what became known as the Bataan Death March. Dr. Saldivar spent 40 months in Japanese POW camps. POWs knew him as the "Angel of Mercy" for his care of them in what was horrendous captivity. (Courtesy of Dolores Saldivar Brown.)

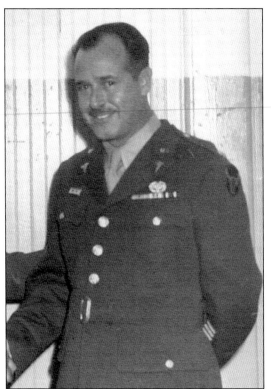

After the war, Dr. Saldivar eventually settled with his young family into a two-story house on Cole Avenue at Hall Street, located on the northern edge of Dallas's Little Mexico. He had his medical offices downstairs, while his family lived upstairs. His wife, Maria, was the nurse in his office. Due to the torture he experienced at the hands of the Japanese, he was no longer able to perform surgery, so he settled into a pediatric practice. Along with fellow Pacific theater naval veteran Dr. Anthony de Haro, Saldivar became a well-known and respected individual throughout Spanish-speaking Dallas. This 1946 photograph shows Lt. Col. Julian T. Saldivar on his return to Texas. He received several military honors for his wartime service, including the Presidential Unit Citation with Oak Leaves. (Courtesy of Dolores Saldivar Brown.)

Every Veterans' Day, dozens of Little Mexico's former soldiers, sailors, and airmen and women gather at the old barrio's Pike Park. This photograph from the 2008 Veterans' Day Pike Park celebrations shows a group of former soldiers in front of the recreation center, flanked by the North Dallas High School ROTC Honor Guard. Joe Alvarez, of the U.S. Army, is sitting on the far left. Andy Cruz, who served as a Marine in the Korean War, is standing fifth from the left. (Courtesy of Joe Alverez.)

Five

THE DEATH OF THE BARIO
LAND GRABS AND GENTRIFICATION

By the 1960s, Little Mexico was dying. Two major transportation projects, the building of North Central Expressway on the barrio's eastern edge and the construction of the Dallas North Tollway on the neighborhood's western boundary, began to physically dismantle Little Mexico. The neighborhood, which had depended so much on the railroads for its development, now saw freeways and roads begin to strangle its growth.

Also taking note of the area's hard times were land speculators and developers keenly aware that the older Hispanic residents of the barrio were easy targets for exploitation. Speculators, often with the help of equally unscrupulous Mexican American "businessmen," basically robbed many residents of their homes in Little Mexico.

By the 1980s and 1990s, more broad-vision developers saw the need for prime office space and high-end residences near downtown. Large-scale planned development followed. By the end of the 20th century, only a handful of Little Mexico's residents still had their homes, and an even fewer number of businesses remained in the area.

The 1950s in Little Mexico were no different from the 1950s anywhere in America. Baby Boomers were young teenagers enjoying fast hot-rod cars and the new music of the post-war period. In this early 1950s picture, a group of teenagers pose on their ancient car. From left to right are Juan "Johnny" Gonzalez, Henry "Blue" Martinez, Pablo "El Pepino" Hernandez, and standing at the rear, Longino "El Pelon" Martinez. It seems everyone had a nickname in Little Mexico. To this day, most former residents of the barrio still identify their old friends through their nicknames. Note, too, that Blue Martinez is not wearing shoes, a condition the photographer attempted to conceal by placing pieces of cardboard over his feet. (Courtesy of Dallas Mexican American Historical League.)

By the 1960s, Little Mexico was showing signs of its age. This 1966 photograph shows the demolition of a building on Harry Hines Boulevard near Moody Street. In the background are the smoke stacks of the Dallas Power and Light Company's (DP&L) coal-burning generating plant. DP&L was just one of the many industrial neighbors with which residents had to contend. (Courtesy of Casa Emanu-el United Methodist Church.)

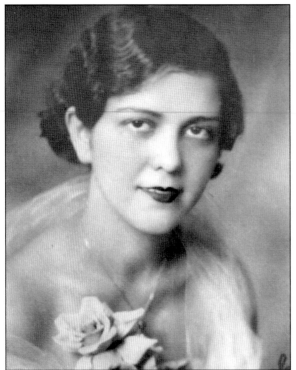

Beginning with Fidel Castro's revolution in Cuba in the late 1950s, various other political and economic conditions resulted in the immigration to Dallas of Spanish-speaking peoples from countries all over Central and South America. Aeida Cassell y Gonzalez, known as Edith Cassell, was born in Cuba in 1916 to an American businessman and a Cuban mother. After her parents divorced, she traveled back and forth between Havana and Dallas regularly. She eventually settled in Little Mexico in the late 1930s. Edith worked in the war plants building bombers during World War II, and with her partner Carmen Gonzalez, she would for decades help hundreds of refugees fleeing Castro's Cuba for Dallas. This photograph of Edith dates from about 1936. (Author's collection.)

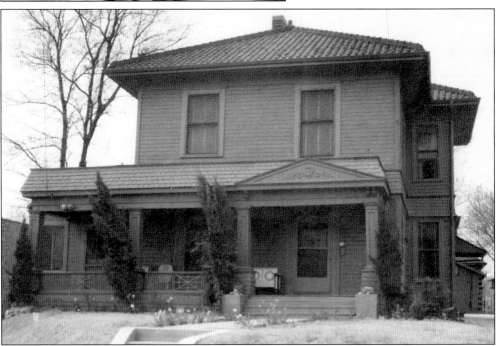

The Little Mexico boarding house, at which Edith Cassell found a home, was owned by Cervando and Maria Martinez and was located at 2537 Cedar Springs Road in the barrio's northern section. It also housed Nena's Beauty Shop for a while. This photograph shows how the boarding house looked in the 1950s. (Courtesy of Rene Martinez.)

La Villita Grocery and Market at 2826 Harry Hines Boulevard specialized in *raspas* (ices and ice cream). Not surprisingly, it catered to a younger crowd. Boys from the barrio pose out front of La Villita in this picture from about 1955. (Courtesy of Dallas Mexican American Historical League.)

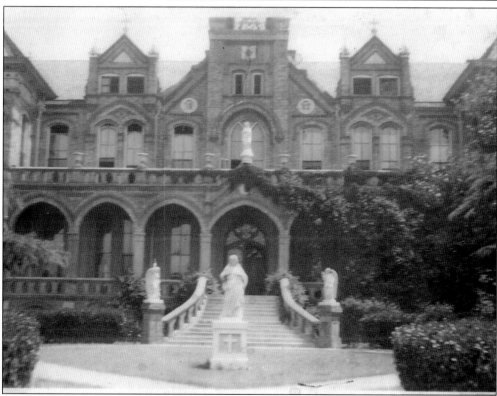

St. Paul Hospital was originally located just east of downtown Dallas in this imposing structure. The Sisters of Charity operated the hospital as they did the St. Ann's School in Little Mexico. Some of the sisters began taking surplus food to Little Mexico for distribution to the needy. Their operation evolved into the Marillac Center. (Courtesy of Catholic Diocese of Dallas.)

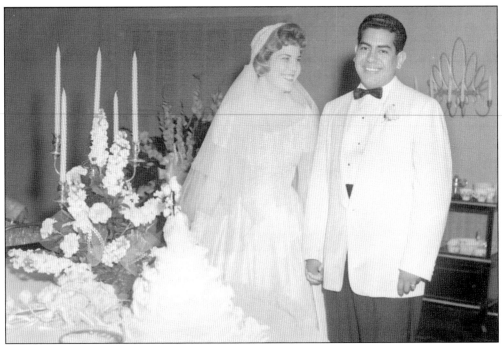

In 1957, Paul Guererro Jr., an aspiring jazz musician, married Celeste Roberts. This photograph is from their wedding reception. (Courtesy of Celeste Guererro.)

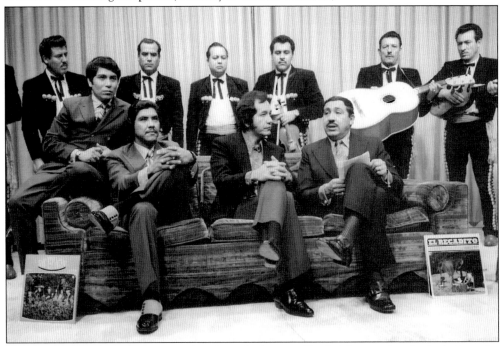

In the early 1950s, Trini Lopez was a boy from the barrio of Little Mexico when he broke into the national music business. He went on to star in several movies and enjoyed a successful recording career. Here Lopez is seated in the center of the sofa during a break of Johnny Gonzales's TV show in about 1959. (Courtesy of the Dallas Mexican American Historical League.)

Alfredo "Fred" Casarez (left) was a well-known musician in Little Mexico. He is seen here in the 1950s with Andy Cruz. (Courtesy of Dallas Mexican American Historical League.)

Internationally known bandleader Xavior Cugat (in the light suit, shaking Henry Lopez's hand) is seen visiting the set of Fred Casarez's weekly television show in the 1950s. (Courtesy of Dallas Mexican American Historical League.)

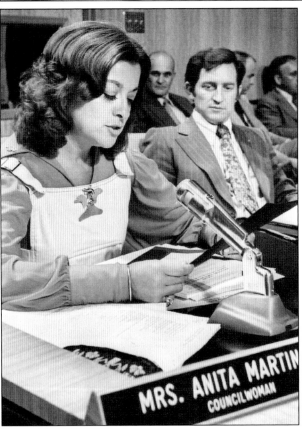

By the 1960s, times were
changing politically, as well as
socially, for Dallas's Hispanics.
Pressure from more active, young
Chicanos forced city power
brokers to support a Hispanic
for the Dallas City Council.
Anita Nanez Martinez was
selected by the Dallas Citizens
Charter Association, the political
organization for downtown
businesses, as the candidate.
In the 1960s, she became the
city's first Hispanic to sit on
the city council. (Courtesy of
Anita N. Martinez Archive.)

Anita N. Martinez went on to
become an effective and vocal
member of the Dallas City
Council during the 1960s. She
fought for more funding for parks
and recreation facilities for Dallas's
growing Hispanic population, as
well as other measures important
to Latinos. This late 1960s
photograph shows Martinez on
the council at city hall. (Courtesy
of Anita N. Martinez Archive.)

Anita N. Martinez would continue to inspire young Latinos even after she left the city council. She became especially involved in arts projects. This 1978 photograph shows Anita and Paul Guererro Jr. at Richland Community College at the college's Hispanic Heritage Month celebrations. Paul taught music for years at the community college. (Courtesy of Celeste Guererro.)

This 1972 photograph shows Paul Guererro Jr. as the guest drummer for the Dallas Symphony Orchestra. (Courtesy of Celeste Guererro.)

Trini Garza, far left, was an engineer by training but answered the call to public service when he became, in 1969, the first Hispanic to be elected to the Dallas Independent School District's Board of Trustees. (Courtesy of Casa Emanu-el United Methodist Church.)

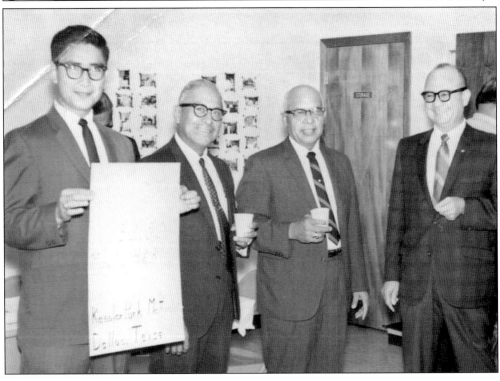

Pedro "Pete" Aguirre, who attended St. Ann's School in Little Mexico as a boy, became a successful architect. He also was elected to the Dallas City Council. This picture of Pete dates from the 1980s. (Courtesy of Dallas Mexican American Historical League.)

These Little Mexico teenagers show off their hot-rod in this 1960s picture. Shown in the photograph are, from left to right, ? Santos, Rudy Trevino, and Maria Rodriguez. (Courtesy of Dallas Mexican American Historical League.)

This photograph from 1966 shows the massive grain elevators and silos west of Harry Hines Boulevard in Little Mexico. The dust from these silos was one of the many environmental hazards the residents of Little Mexico faced daily. (Courtesy of Casa Emanu-el United Methodist Church.)

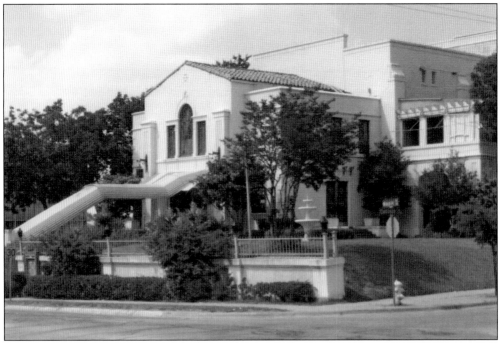

When J. J. Rodriguez sold the building and property of the Cine Festival in 1983, the new owner, a commercial real estate company, proposed to tear down the historic structure. After resistance from preservationists, the developer bulldozed the important building, seen in this 1960s picture, in the dead of night. (Courtesy of Mariangel Rodriguez.)

Six

TODAY

PLACE, MEMORY, AND NEW GROWTH

No place ever really dies. Little Mexico may have disappeared, but just about every Mexican American resident in Dallas has heard of the old barrio—even if they do not know where it once existed. Fortunately, a few structures from the neighborhood's past still remain and have been put to good use. Pike Park still hosts all fashions of Mexican American celebrations, St. Ann's School has been incorporated into St. Ann Court, a mixed-use, high-rise commercial complex, Cumberland Hill School is beautifully preserved as an office building, and Old Parkland Hospital has recently undergone renovations to transform it into an office complex set amidst the wonderful oak trees that have graced the site since its days as a park more than 100 years ago.

Variously called Uptown, Victory Plaza, or the Harwood District, the sites of Little Mexico's churches, schools, homes, and businesses now host grand hotels, clubs, high-rise condos, and the American Airlines Center, one of the premier entertainment venues in north Texas. So popular has the area become that a concern over parking was the final straw for the remaining businesses of Little Mexico.

An 1878 Dallas city directory listed two Spanish-surnamed residents. Today, Dallas's Hispanic population has exponentially increased. Hispanic children make up more than 60 percent of the Dallas Independent School District's enrollment. This new growth has and will continue to change and improve Dallas. Indeed, it makes richer the entire nation.

The Mongoras Grocery and Market was located at 2606 Caroline Street at the southern edge of Little Mexico. The Mongoras family finally sold their property when the Victory Plaza entertainment/hotel district began to develop along the west side of Harry Hines Boulevard. This photograph looks south along Moody Street today. The Mongoras Grocery stood near the far end of the curve. (Author's collection.)

This present-day picture was taken at Pike Park, looking southeast, just like the photograph on pages 20 and 21 of the Fourth of July celebration at the park. (Author's collection.)

The modest St. Ann's School Building, now a city landmarked site, sits at the foot of the St. Ann Court Office complex, which opened in 2009. The St. Ann Restaurant occupies the lower floor of the old school. Consistent with the building's decade-long educational purpose, the second floor houses the Ann and Gabriel Barbier-Mueller Museum: The Samurai Collection. (Author's collection.)

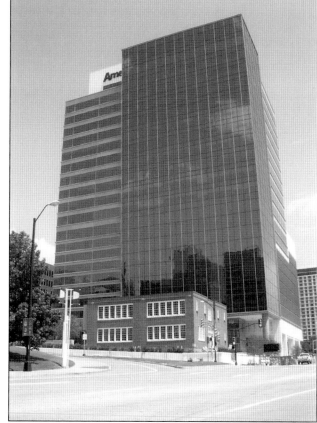

The recreation center at Pike Park is still situated between the few trees of the small park. This current photograph shows the eastern and northern facades. Celebrations dear to Dallas's Hispanics continue to be held at the park. (Author's collection.)

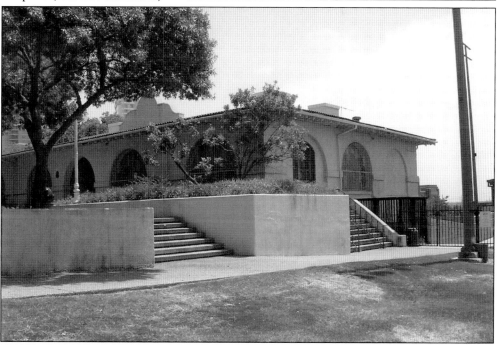

The old Parkland Hospital was completely renovated in the first decade of the 21st century, and the building now serves as offices for Crow Holdings. This photograph shows the main building, which faces Maple Avenue. (Author's collection.)

The KATY Railroad tracks are long gone from the area that was Little Mexico. Following the old rail bed now is the KATY Trail. It stretches from Victory Plaza, just north of downtown, through the heart of the city. The KATY Trail is very popular with joggers, bikers, and others attracted to nature in an urban setting. This picture looks south along the trail toward the American Airlines Center. A nearby plaque, recently erected by the city, totes the recovering of such wonderful green space from this once heavily industrial and polluted area. The plaque makes no mention of Little Mexico or its people. (Author's collection.)

This modest home still sits across Harry Hines Boulevard from Pike Park where it has stood for decades. It is one of fewer than a dozen old houses remaining from Little Mexico's heyday. (Author's collection.)

The view south along Harry Hines Boulevard in what was once Little Mexico is unrecognizable today compared to just 30 years ago. This is the same view as the photograph on page 85. (Author's collection.)

The American Airlines Center is one of the crown jewels in Dallas's Victory Plaza entertainment area. This present view of the center, posh hotels, and high-rise residences looks south down Houston Street in what was Little Mexico. (Author's collection.)

When the old St. Ann's School was threatened with demolition, several groups came together to force the city to designate the structure as a historic landmark, which the city did in 1999. This photograph from that year shows awards being given to several persons involved in saving the old school at the building site. From left to right are the Honorable Anita N. Martinez, Julia Cabrera and her son and daughter Joseph and Esperanza, and the author, who was the attorney responsible for landmarking. (Courtesy of Rella Alvarez.).

This old retaining wall along Harry Hines Boulevard is the only reminder that a Little Mexico family once called this spot home. In this photograph, office towers and other modern buildings look down on stairs that now lead nowhere. (Author's collection.)

Discover Thousands of Local History Books
Featuring Millions of Vintage Images

Arcadia Publishing, the leading local history publisher in the United States, is committed to making history accessible and meaningful through publishing books that celebrate and preserve the heritage of America's people and places.

Find more books like this at
www.arcadiapublishing.com

Search for your hometown history, your old stomping grounds, and even your favorite sports team.